LOST
PASSENGER STEAMSHIPS
of
LAKE MICHIGAN

LOST
PASSENGER STEAMSHIPS
of
LAKE MICHIGAN

Ted St. Mane

Published by The History Press
Charleston, SC 29403
www.historypress.net

Copyright © 2010 by Ted St. Mane
All rights reserved

Front and back cover images: *Courtesy of the author and the Library of Congress.*

First published 2010

Manufactured in the United States

ISBN 978.1.59629.942.9

Library of Congress Cataloging-in-Publication Data

St. Mane, Ted.
Lost passenger steamships of Lake Michigan / Ted St. Mane.
p. cm.
Includes bibliographical references.
ISBN 978-1-59629-942-9
1. Inland water transportation--Michigan, Lake--History. 2. Passenger ships--Michigan, Lake--History. 3. Lake steamers--Michigan, Lake--History. 4. Fires--Michigan, Lake--History. 5. Disasters--Michigan, Lake--History. 6. Shipwrecks--Michigan, Lake--History. 7. Michigan, Lake--Description and travel. 8. Michigan, Lake--Navigation--History. 9. Michigan, Lake--History, Naval. I. Title.
HE630.M5S7 2010
917.74'04--dc22
2010022981

Notice: The information in this book is true and complete to the best of our knowledge. It is offered without guarantee on the part of the author or The History Press. The author and The History Press disclaim all liability in connection with the use of this book.
All rights reserved. No part of this book may be reproduced or transmitted in any form whatsoever without prior written permission from the publisher except in the case of brief quotations embodied in critical articles and reviews.

Contents

Preface	7
Acknowledgements	9
1. Vanished Industry	11
2. Immigration and Westward Expansion	29
3. The Passenger Experience	47
Breakfast	60
Lunch	61
Dinner	62
Burning of the Propeller *Phoenix*, 1847	67
Burning of the Steamer *Niagara*, 1856	68
Loss of the *Lady Elgin* on Lake Michigan, 1860	68
Loss of the Propeller *Hippocampus*, 1868	69
Steamer *Sea Bird* Burned, 1868	71
Steamer *Vernon* Sinks in Lake Michigan, 1887	71
4. Working the Lakes	73
5. Early Twentieth-Century Steamers	91

CONTENTS

6. War on the Lakefront 111
The Black Hawk War 111
The Civil War 118
Spanish-American War 122
World War I 123
World War II 132

7. The Last Generation 141

Notes 147
Glossary 155
About the Author 159

Preface

Lake Michigan is one of five freshwater lakes located on the border of the United States and Canada known as the Great Lakes. From east to west, the Great Lakes are Ontario, Erie, Huron, Michigan and Superior. Together they form the largest group of freshwater lakes on Earth. Lakes Michigan and Huron are, in terms of hydrology, a single lake with the same surface elevation, connected by the Straits of Mackinac.

The history of passenger steamship travel on Lake Michigan is inseparable from that of travel on the Great Lakes as many of the steamer routes passed among the lakes. In fact, the linking of the Great Lakes, via river improvements and canals, into one great waterway was an extremely important achievement in promoting westward expansion of the United States in the nineteenth century.

Within this work, a great number of direct quotes from publications and personal accounts of travel have been included in order to give a clear sense of the experiences and conditions on Lake Michigan during the era of passenger steamships. Unusual, British or period spellings and grammatical usages have been left unaltered within quotations.

The terms *steamer*, *steamship* and *steam boat* are used interchangeably within the text and quotes of this book. While in naval terms, a boat is a craft small enough to be carried aboard another vessel, the Great Lakes have spawned their own rules with the steamers of the lakes being commonly referred to as both ships and boats.

Acknowledgements

The author would like to gratefully acknowledge the assistance of the many people and organizations that contributed information and shared resources to make this book possible. Among them are numerous historic preservation enthusiasts, archivists and organizations throughout the Great Lakes region that have worked diligently to preserve important records of our collective past. Histories like this one would be impossible if not for the historical documents that were recorded as current events by a long succession of newspapers and other publications. Additionally, earlier histories of the region—most published prior to 1900—have provided invaluable information for this book. Of particular importance to this project were the resources of the Library of Congress, the Department of the Navy–Naval Historical Center, Bowling Green State University and my personal collection of passenger steamer histories and images, which have been contributed to by a number of generous collectors over the years.

Chapter 1

Vanished Industry

Fifteen Steam-boats make a mile: this is a new rule of arithmetic, only found out in America, and I mention it because it is much more easy than to remember that they are three hundred and fifty feet long each.
—Thomas Horton James, 1845

There was once a flourishing passenger steamship industry on the Great Lakes characterized by grand vessels steaming majestically along deeply wooded shorelines, past emerald isles and across the deep turbulent waters of America's inland seas. This industry has regrettably all but vanished and is today mostly recalled through stories, images and other relics. In extreme limits the use of passenger steamships on Lake Michigan can be expressed as the years between 1821 and the present, as the steamship *Badger* still plies the waters of Lake Michigan between Manitowoc, Wisconsin, and Ludington, Michigan, carrying automobiles and passengers much as she has since 1953. However, the robust years of passenger steamship travel on Lake Michigan make a smaller span. This era may be best described as the 110 years between the 1830s and the 1940s when numerous steamships regularly plied the waters of Lake Michigan carrying passengers and cargo. Even this estimation is generous, as the decline of the Lake Michigan passenger steamer became almost epidemic as early as the Great Depression of the 1930s.

The first passenger steamship to venture onto the waters of Lake Michigan was called *Walk-in-the-Water*, a side-wheel paddle steamer built for the Lake Erie

Lost Passenger Steamships of Lake Michigan

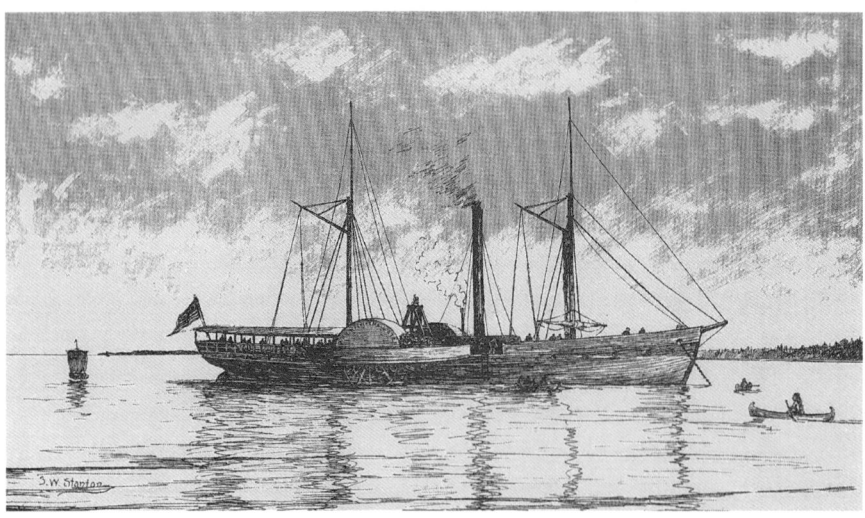

This illustration by Samuel Ward Stanton shows *Walk-in-the-Water*, which was the first steamship on Lake Michigan. *Courtesy of the Library of Congress.*

Steam-Boat Company. The ship was powered by a single low-pressure steam engine designed by Robert Fulton while also equipped with two schooner-rigged masts. Her usual route, carrying passengers and cargo, was across Lake Erie between Buffalo, New York, and Detroit, Michigan, and later between Detroit and Mackinac Island at the northern end of Lake Huron.

Launched at Black Rock, New York, on August 23, 1818, *Walk-in-the-Water* had already been in service for nearly three years when on July 31, 1821, she left Detroit on a thirteen-day, 1,200-mile round-trip journey that took her through the Straits of Mackinac and across Lake Michigan to deliver a cargo of general merchandise and 200 passengers to Green Bay, Wisconsin.[1]

While *Walk-in-the-Water*'s journey initiated steamer navigation on Lake Michigan, it did not lead to an immediate boom in steamship traffic on the lake. *Walk-in-the-Water* herself was caught in a storm and driven ashore near Buffalo less than twelve weeks after her only trip to Lake Michigan. The ship was too badly damaged to be saved, and Green Bay did not receive another steamship visit until four years later with the arrival of the *Henry Clay* in 1825.

The next year, Thomas L. McKenny gave this account of his travels aboard the *Henry Clay*:

Vanished Industry

The steamboat **Henry Clay**, *in which I made my first Lake voyage, is one of the first class. She is schooner rigged, and has a depth and beams suited to the use of sails, when these are needed, and her timbers are stout and well put together, that she might endure the shocks of the inland sea, and the stormy route for which she is built. In this fine boat I left Buffalo in the company with some 30 cabin and perhaps 40 deck passengers, the latter chiefly emigrants from New York and the New England states, to this territory, and three Indians. The steamboats* **Superior** *and* **Henry Clay** *are surpassed by few, if any, either in size or beauty of model, or in the style in which they are built and furnished.*

On September 3, 1829, the *Detroit Gazette* reported on the *Henry Clay*'s continued service from Detroit, Michigan, to Green Bay, Wisconsin:

The steam boat **Henry Clay**, *Captain Norton, departed from this port on Sunday last, for Green Bay. She had a very considerable number of passengers in the cabin, and a detachment of 250 U.S. troops for the posts on the upper lakes. Majors Gwynne, Larned and Kirby, of the U.S.*

For small communities dotting the shores and islands of Lake Michigan, steamers were important links for supplies, news and transportation. *Courtesy of the author.*

13

Army, and Messrs. Abbott, Biddle and Gray, of this city, were among the passengers.

Despite emerging steamship service, the rise of passenger steamships on Lake Michigan was hindered by a variety of factors seen by ship owners of the period as making steamships less profitable than sailing vessels. Chief among these concerns were the cost of building steamships, whose expensive engines could more than double the price of construction, and the cost to operate them given their voracious appetites for wood fuel. Sailing schooners were generally cheaper to build and much cheaper to operate as they required fewer crew and utilized a free power source, the wind. A typical wood-fueled steamer in 1830 consumed "about 26 cords of wood per day, a cord consisting of about 128 cubic feet, selling for $1.50 to $3.00 per cord."[2] In 1830, $3 equated to approximately $72 today. Hence the $39- to $78-a-day cost of wood fuel in 1830 would amount to between $936 and $1,872 in today's economy.[3] The room taken up by the steam engine, equipment and fuel also meant less room for cargo and passengers, upon which the ships depended for profit.

Navigational deficiencies, such as inadequate harbors and dangerous sandbars at Milwaukee, Chicago and other ports, were also a barrier to early steamship traffic on Lake Michigan.

> *Lake Michigan occupies more surface than the State of New York, and the productive, unoccupied lands bordering it would sustain a population greater than that of all the New England States. And yet there are hundreds of miles of coast, upon this lake, whose waters float hundreds of vessels burdened with millions of dollars, where the government has not yet expended the first dollar for a harbor! There is a lighthouse, to be sure, on Washington Island in Green Bay, which warns the mariner of that danger, but if he is in a gale, or needs a harbor, he may run over an hundred miles without finding one.*[4]

In 1835, 180 schooners—and only two steamers—reportedly visited Milwaukee. However, the tide was about to turn, and, by 1839, the number of annual steamship arrivals at Milwaukee had edged past that of schooners. One catalyst for this change had its origins in the 1825 opening of the Erie

Vanished Industry

Canal. At that time the United States consisted of twenty-four states and several territories. Illinois and Indiana, with their access to Lake Michigan, were among these states, but the area to later become Michigan and Wisconsin was still the Michigan territory. The opening of the 363 miles of the Erie Canal, from Albany to Buffalo in New York state, created an important water route between the Hudson River and the Great Lakes. This significantly increased accessibility of the interior from the East Coast and greatly encouraged the growth of commerce and migration into Illinois, Indiana and the territory surrounding Lake Michigan.

Demand for passenger transportation swelled as New England migrants made their way west, tempted by prospects of abundant land and a new life. This increased passenger demand in turn created the financial justification for investments in steamboats for service on the Great Lakes—chiefly Lake Erie. In the thirteen years before the opening of the Erie Canal, only twenty-five steamboats had been constructed for Great Lakes service. Following completion of the canal, sixty new steamships were built for use on the lakes in just four years.[5]

The first steamships on the lakes were side-wheel, paddle-wheelers, often identified by newspapers as steamers, while the propeller-driven steam vessels of the next generation of lake ships were initially referred to as propellers, with the occasional use of the inventive spelling, "propellors."[6]

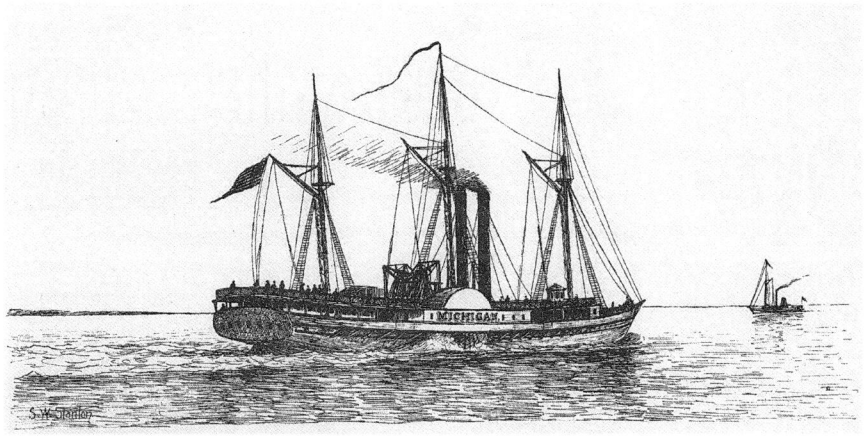

The steamer *Michigan*, shown in this illustration by Samuel Ward Stanton, was built in 1833 for the Buffalo–Detroit route and also ran to Chicago and Milwaukee. *Courtesy of the Library of Congress.*

One of the earliest steamers to ply Lake Michigan and make calls at Green Bay and Milwaukee was the side-wheeler *Monroe*. In 1837, the *Milwaukee Sentinel* claimed that the *Monroe* had, in July of 1836, earned the distinction of being the first steamboat to enter the Milwaukee harbor.

Enthusiastically described as "a fine high pressure boat of about three hundred and fifty tons burthen, superbly finished and furnished, and in point of safety, convenience, speed and beauty, is exceeded by few if any," the *Monroe* was originally owned by the River Raisin Steam-Boat Company and was built at Monroe, Michigan territory, in 1834.

On October 8 of that same year, the *Buffalo Whig* in Buffalo, New York, reported:

> *The new Steam Boat* Monroe, *Capt. H. Whittaker, came into this port, for the first time, on Thursday morning last. Her Gentlemen's Cabin, has 33 berths, Ladies [Cabin] 12 [berths] and 4 State Rooms, Forward [Cabin] 51 [berths] and Steerage [berths] 20. This boat is certainly of fine appearance, and is very handsomely finished. She came in, in the morning, during a heavy gale, which she had buffeted the whole night. Her Captain informs us he has seldom seen a worse night upon the lake.—The sea stove a boat suspended astern, and carried it away, making a full breach into the cabin windows, and over the deck at the same time. With such a christening, and acquitting herself well, as she did, her reputation as a sea boat, is established.*

George William Featherstonhaugh, the first official geologist of the United States, traveled aboard the steamer *Monroe* to Green Bay in 1835 as part of a trip into the Michigan and Wisconsin territories.

> *On the 17th I was awoke early with the intelligence that the steamer* Monroe *had arrived in the night from Sault St. Marie, and was bound to Green Bay. Nothing could be so opportune for my plans; so sending my luggage on board, I hastily breakfasted, and going on board, had the pleasure of finding Mr. Schoolcraft there, who had also determined upon the trip. As we stood out of the bay, I was struck with the great beauty of the scene; the lofty island, the old French fort conspicuous in the distance, the American fort, of a dazzling whiteness, just above the town, and numerous*

groups of Indians standing near their lodges to view the departure of the steamer, which moved on in gallant style with four Kentish bugles playing a lively air, concurred to produce one of those rare effects which a traveler sometimes witnesses.

Alfred Theodore Andreas noted in his 1884 *History of Chicago* the importance of emerging steamer access to the Chicago River and the commencement of regular steamer service to Chicago in the early 1830s.

In 1834 three steamboats landed at Chicago and two at Green Bay. Such was the advent of steamers and schooners into Chicago River, and the heart of the growing town was at last connected with the navigable heart of the great Northwest. Soon afterward a large class of steamers commenced making regular trips from Buffalo [to Chicago], *touching most of the intermediate ports. Among the number was the* "James Madison," *owned by Charles M. Reed, of Erie, and built with particular reference to the upper-lake trade. Her capacity for freight and passengers was the largest upon the lake at that time.*[7]

By 1839, regular steamer routes had been established to carry merchandise and passengers to and from the cities and towns of the Lake Michigan area, although the ports accessible by these steamers were on the western shore of the lake since significant improvements in harbors had not yet been undertaken elsewhere.

The increase of business to Chicago and ports west of Detroit, in 1839, had become so large that a regular line of eight boats, varying in size from 350 to 650 tons each, was formed to run from Buffalo to Chicago, making a trip in every sixteen days. The increase in the business was by emigrants with their household furniture and farming implements, and others going west, and not from any freight from Lake Michigan, as the rapidly increasing population of that section of the country required provisions to be imported into rather than exported from it.[8]

With increased steamship service, there followed a rapid advancement in steamship design during the late 1830s and 1840s. Two steamers exemplary

Lost Passenger Steamships of Lake Michigan

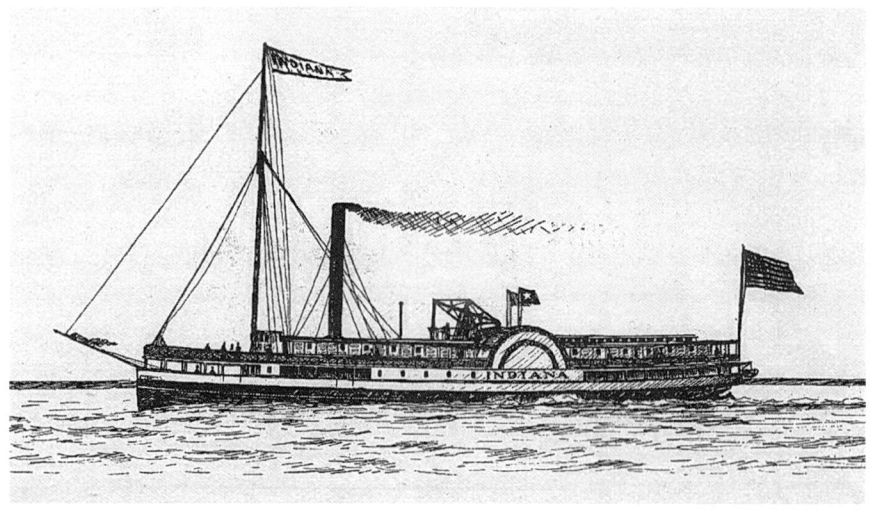

This illustration by Samuel Ward Stanton shows the *Indiana*, which was an example of the first class of lake steamers to carry a large upper-passenger cabin. *Courtesy of the Library of Congress.*

of this period were the paddle wheel steamers *Illinois* (built 1837) and *Great Western* (built 1838). A description of the *Great Western* appeared in J.B. Mansfield's 1899 *History of the Great Lakes*:

> The 185-foot Great Western was the first steamer on the Lakes to be fitted with a spacious upper cabin. The entire hull was occupied by the boilers, with holds for freight and wood. On the main deck aft was the ladies' cabin and staterooms, while on the hurricane deck the main cabin extended almost the entire length of the boat. On this deck there were also a ladies' saloon aft, the dining room next, and the saloon or bar-room forward. Staterooms, 60 in number, were arranged on either side of these cabins, the whole length, with three berths in each, making in all about 300 berths.

The *Black Rock Advocate* carried in its pages on January 27, 1837, the following article describing the *Illinois* under construction:

> *A NOBLE SHIP—THE* ILLINOIS.—*We are happy to learn that a new and splendid Steam Ship, far surpassing any thing that has yet been*

> *put afloat on our western waters, is now building at the ship yard of O. Newberry in this city. We have been favored with the following description of the vessel. Length of keel 194 feet. Length on deck 200 feet. Depth of hold 13 feet. Breadth of beam 30 feet. Breadth including guards 60 feet. Burthen about seven hundred tons. She will be propelled by a low pressure engine from the manufactory of James P. Allaire, of New-York, of the following dimensions: Diameter of cylinder, 26 inches. Length of stroke, 10 feet. Diameter of water wheel, 23 feet. The vessel we are informed will be ready by the first of August next. For the last season, the business on the Lake has far exceeded the capacity of the shipping, notwithstanding the great increase of the latter. The disproportion will be probably quite as great next season. At such a time the construction of such a vessel as the* **ILLINOIS** *cannot fail to be equally profitable to the owners and the public, as well as creditable to our city.*

The *Illinois*, intended to be "the most splendid steamboat on the Lakes" was officially launched at Detroit on the 23rd of August 1837. At 755 tons burthen she was reported at the time to be, "the largest boat ever put afloat on the western lakes."[9]

The *Illinois* was further described as "a great favorite with the traveling public" and "very fortunate and successful" in carrying freight, passengers and goods to and from Chicago. In the summer of 1844, Captain Johan Gasmann, a saltwater ship captain who carried immigrants from Norway to America, decided to make a trip to Wisconsin to visit his brother, Hans, who had settled there earlier.

In a letter written after his return from the west, Captain Gasmann described his trip across the lakes on the *Illinois*:

> *I left Buffalo for Wisconsin on board the steamboat "Illinois," Captain Blake commanding. This trip took four days. The ship's commander was very kind to me, and being himself an old saltwater seaman, it pleased him to have me as a passenger, and consequently I obtained free passage both going and returning. The steamboat used firewood in place of coal, and that is the case with all the steamships which sail on the Lakes. Consequently we took on fuel at several places en route on the voyage from Buffalo to Milwaukee. After we had passed the Strait of Mackinac, Lake Michigan*

was spread before us with its dark blue surface. This is the longest as well as the deepest of all the lakes.[10] *Its depth in the middle is supposed to be almost three hundred fathoms, but it is also supposed to abound in fish.*

The steamboat now made from the Michigan shore and set its course for Milwaukee. The shore disappeared over the horizon behind us. A considerable swell came against us and also to port, so that the steamboat rolled somewhat, and the outboard gangplank often plunged down into the surface of the water and caused violent tremors in the whole ship. I do not regard these long, three-storied steamships as seaworthy vessels, and the captain on the boat said to me that often in the autumn, when storms occurred, he had difficulty enough in navigating the Illinois.

Among the steamers serving Lake Michigan in the season of 1841 were six boats of the largest class running "from Buffalo to Chicago, making fifteen day trips, and one to Green Bay a part of the season." It is worth noting that in the season of 1841 there was a more significant amount of return cargo from the Lake Michigan ports to the east, which accounted for some of the increased profitability of the lines.

The Chicago and Green Bay boats earned, in 1841, the sum of $301,803 from the increased quantity of agricultural productions brought from the shores of Lake Michigan this season, also a good many tons of lead and shot from the mines in that section of the country, now, for the first time, in any considerable quantity, seeking a market by the lake route. I estimate that three-fourths of the business done by the Chicago and Green Bay boats this year is made from legitimate business west of Detroit, and amounts to $226,352. Business is found to have grown, in the short period of seven years, from 1834 to 1841, from the trifling sum of $6,272 to the magnificent amount of $226,352.[11]

The $226,000 in steamship revenue gained "west of Detroit" in 1841 would equate to over $115 million today.[12]

Continued advances in shipbuilding technology during the 1840s, including development of new fastenings for wooden hulls, the expanded use of ironwork for strengthening and the introduction of *hogging-frames* and trusses gave rise to the construction of a series of lavish palace steamers of

Vanished Industry

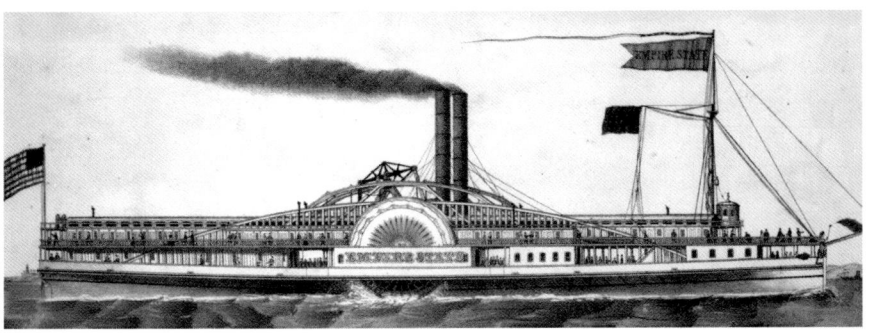

The 310-foot-long, 1,700-ton side-wheel steamer *Empire State*, shown in a drawing by Currier & Ives, was a palace steamer on the Buffalo–Chicago route. *Courtesy of the Library of Congress.*

unprecedented size and splendor between 1844 and 1857. Considered at the time to be "the most beautifully-appointed craft ever built on the Lakes," twenty-five of the vessels were constructed, most of which were between 1,000 and 1,600 tons. The largest and the last was the *City of Buffalo*, built in 1857. At 2,026 tons and measuring 350 feet in length, this impressive steamship was overawing to observers as described by the *Buffalo Morning Express* on July 25, 1857:

> *The grand cabin* [is] *lighted by skylights and a splendid stained-glass dome. On either hand the doors open into the staterooms. The cabin has an arched ceiling, which together with the panels, are ornamented by gilt mouldings, the white and gold making a very rich appearance. Splendid chandeliers light it by night, the center one being double. The furniture is of the richest rose-wood, with damask and plush upholstering; the carpets are costly Brussels, and the whole scene magnificent. The fairy palaces of the imagination were never so gorgeously furnished, nor could the famous barge of Cleopatra, with its silken sails, rival this noblest of steamers.*

J.B. Mansfield's 1899 *History of the Great Lakes* reports that, "The Panic of 1857 ruined the passenger business on the Lakes. The entire fleet of Palace Steamers was withdrawn from service. Few ever operated again. When the country recovered from the depression in 1861 and 1862, most of the ships were no longer worth repairing, and they were too expensive to compete with newer, more efficient craft. The passenger business revived after the

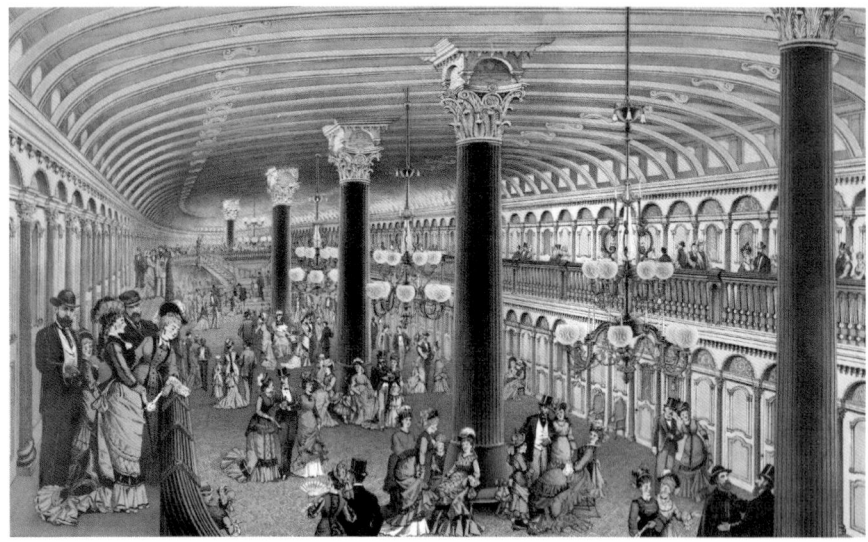

An illustration by Currier & Ives depicts the lavish grand saloon of a palace steamer. *Courtesy of the Library of Congress.*

Civil War, but it was never again able to sustain ships as luxurious as the Palace Steamers. The steamers built for the post-war passenger trade were more modest in size and furnishings."

The development of propellers—steamships driven by a screw shaft propeller rather than by a rotating mechanism of paddles at the sides or rear of the vessel—was accelerated in the 1840s in part due to the limitations of side-wheel steamers. The bulky engines of the side-wheelers reduced their cargo capacity, and their necessarily broad beam, or width, made them too wide to negotiate many of the canal and lock systems of the day.

In the early 1840s, several vessel owners adopted the efficient new 1301 engines with screw propellers developed for lake use by John Ericsson and first put into service by entrepreneur captain James Van Cleve in the form of the SS *Vandalia* in 1841. Ericsson was also inventor of the Union ironclad USS *Monitor*, which famously fought the world's first ironclad vs. ironclad action against the CSS *Virginia*, sometimes referred to as the *Merrimack*. Though side-wheel steamers remained popular in the passenger trade for many decades—and a few large paddle-wheelers were built on the lakes after 1900—they were destined to be supplanted by the propellers and never again achieved the numbers of their heyday in the 1830s and 1840s.

Vanished Industry

Thomas Horton James, an English visitor to the lakes region, noted in 1845 the plentitude of sail vessels converted to steam power and described them in his writings upon returning to Europe:

> *There is a large traffic on the upper lakes in the conveyance of all sorts of goods, and the lowest classes of Irish and German emigrants, by means of propellers, as they call them, or sailing vessels with a small steam-power attached, in case of calms or adverse winds. The rates of freight and passage by these vessels being only two-thirds of the regular steamers, they obtain plenty of business; and as dispatch is the soul of all American commerce, and 'the summer ends too soon,'* [many] *sailing vessels on the lakes* [have] *the addition of steam, and then they are called propellers.*[13]

The continued development of propeller steamships brought to Lake Michigan the style of passenger steamer most recognized today as typical of the Great Lakes. These propellers were largely of two to three decks and with a pilothouse forward. This is also the form of passenger steamship that was most photographed, which is only natural as photography was in its infancy prior to 1850 and still not widely available until well after the Civil War.

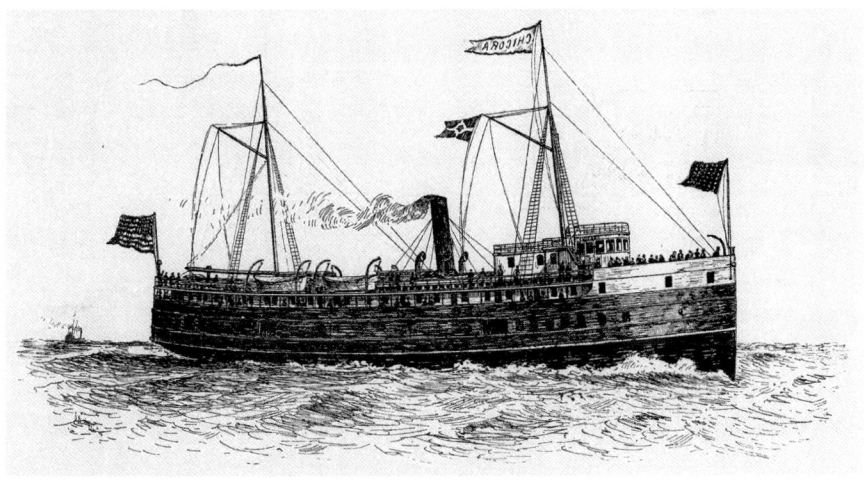

The propeller steamship *Chicora* carried passengers and freight on Lake Michigan until it was lost with all aboard on January 21, 1895. The ship is depicted here by Samuel Ward Stanton. *Courtesy of the Library of Congress.*

From the 1870s through the turn of the century and beyond, propellers were most prevalent of the steamers on Lake Michigan and, with the advent of significant harbor improvements, the era of steamer excursion travel was well underway. Trips between Chicago, Milwaukee and other coastal cities were a daily staple, and resort destinations along the eastern shore of the lake enjoyed a booming business in tourists and vacationers during the warmer months. The lucrative trade in transporting fresh fruit from growers in Michigan to markets in Chicago and elsewhere also corresponded with the primary months of vacation traffic, increasing profitability and sometimes dangerously overloading steamers bound for Chicago.

In the late nineteenth century, summer vacation spots in northern Michigan were accessible primarily only by steamer. With limited rail access to the area and inland roads nearly nonexistent, most tourists from Chicago, Milwaukee and other cities reached the resort towns by steamship. There were many popular Michigan destinations, including Harbor Springs, Charlevoix, Petoskey, Oden and Cheboygan. The route from Chicago to these picturesque locales was served by a number of steamers including the *Manitou*, *North Land*, *Petoskey* and *Charlevoix*. In 1898, the fares were $5 for passage only, and $7 with meals and berth included.

At resort communities all along the eastern shores of Lake Michigan, crowds would gather at the docks on Saturdays and Sundays during the summer months. Motor coaches awaited new resort guests while many well-to-do, summer-home

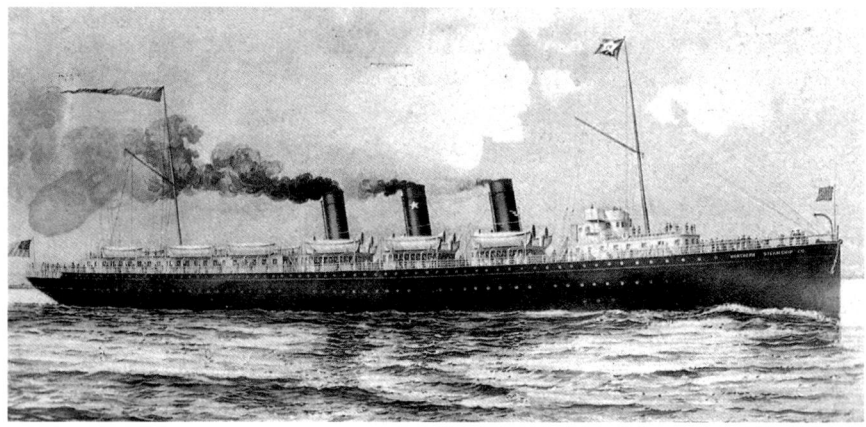

The palatial twin-screw passenger steamship *North Land*, sister ship to the *North West*, launched in January 1895 and served the Buffalo–Lake Michigan route. *Courtesy of the author.*

Vanished Industry

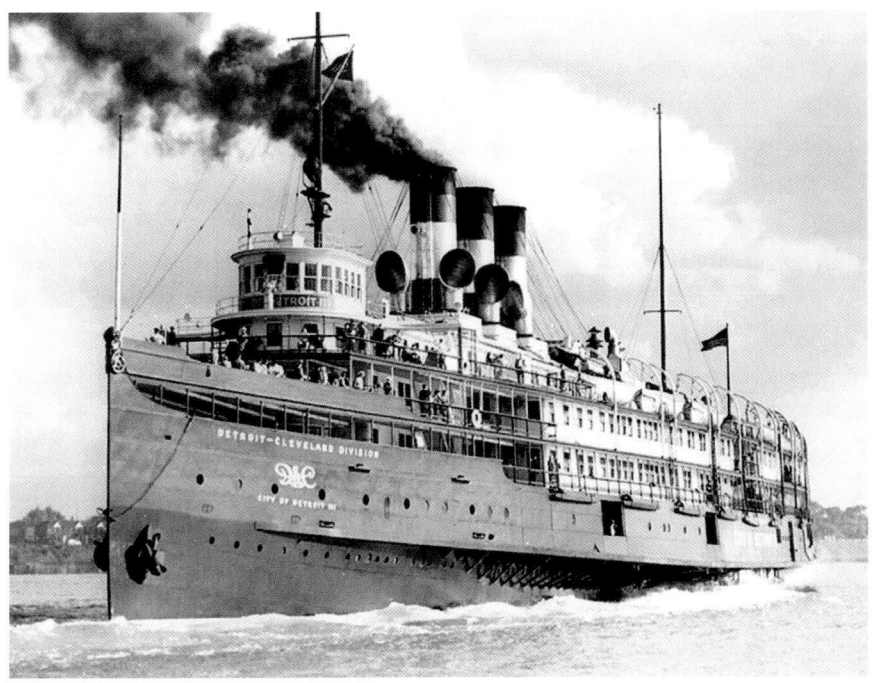

When launched in 1912, the steamer *City of Detroit III* was the ultimate in comfort and style. *Courtesy of the University of Detroit Mercy Library.*

residents—spending weeks or months at summer lodgings—rode to the docks to meet husbands or fathers arriving from the Chicago area. "They leave Chicago Friday night," explained a tourist publication, "and get here the next morning; first stop. They're with their families until Sunday night when the boat takes 'em back again, ready for the job. Great for 'em!"[14]

The 1910s and 1920s were robust years for the American economy, and, despite pressures from the competing railroad industry, fresh investments in new passenger steamships brought a number of fine new—and dramatically larger—ships to the Great Lakes.

> *In construction of the new* City of Detroit III *nothing that money could buy has been omitted in an effort to make the ship the most modern model of shipbuilding skill, combining staunchness of build with the latest approved types of mechanical equipment and every essential to the comfort and care of passengers, with palatial furnishings, fittings and decorations.*[15]

The *City of Detroit III* was the first of four side-wheel passenger steamers that claimed the title of "largest side-wheel steamship on the Great Lakes" between 1911 and 1924. Designed by the noted marine architect Frank Kirby and built for the Detroit, Cleveland and Buffalo route on Lake Erie in 1911, the *City of Detroit III* carried passengers on weeklong cruises from Lake Erie to Lake Michigan and Chicago in the 1930s and 1940s.

Promotions to attract passengers to "cruising the inland seas" were important in keeping the industry afloat, especially after 1930 when the economic upheaval of the Great Depression put some steamship lines out of business and threatened the end of the era of passenger steamers on the Great Lakes altogether. A Great Lakes travel brochure of the time, the *Romance of the Inland Seas*, touted the advantages of passenger steamship travel with the following assessment:

> *For nearly three hundred years the Great Lakes have been the "great links" between East and West. This greatest of inland waterways forms the line of least resistance between Buffalo and the principle cities of the Upper Midwest. From the treacherous bark canoe of the Indian to the modern steel steamships, with every provision for safe traveling, is a mighty step, which has removed the dangers, but not the thrills, of a trip via the Inland Seas.*

Following the steamship decline during the 1930s, there was a temporary increase in passenger traffic on Lake Michigan steamers during World War II; the ocean cruise industry was curtailed due to the dangers of U-boat attacks, and rationing of gasoline and rubber for car tires meant more motorists turned to lake steamers for vacation and other travel. However, the trend was not enough to hold back the end, and one after another the great steamship lines declared bankruptcy or otherwise closed down operations. By 1947, only a handful of passenger steamers still plied Lake Michigan, including the cross-lake car ferries whose unique value made them more resistant to economic upheaval and changing trends in leisure travel.

Near the end of the nineteenth century, a Great Lakes historian lamented, "Year by year the number of real sailors grows less on the lakes. The musical 'heave-ho' is becoming the lost chord. There still exists what we might call a domesticated breed of sailors, such as the quartermasters, who steer our steamships, but the typical Jack of the pre-propeller age has utterly

Vanished Industry

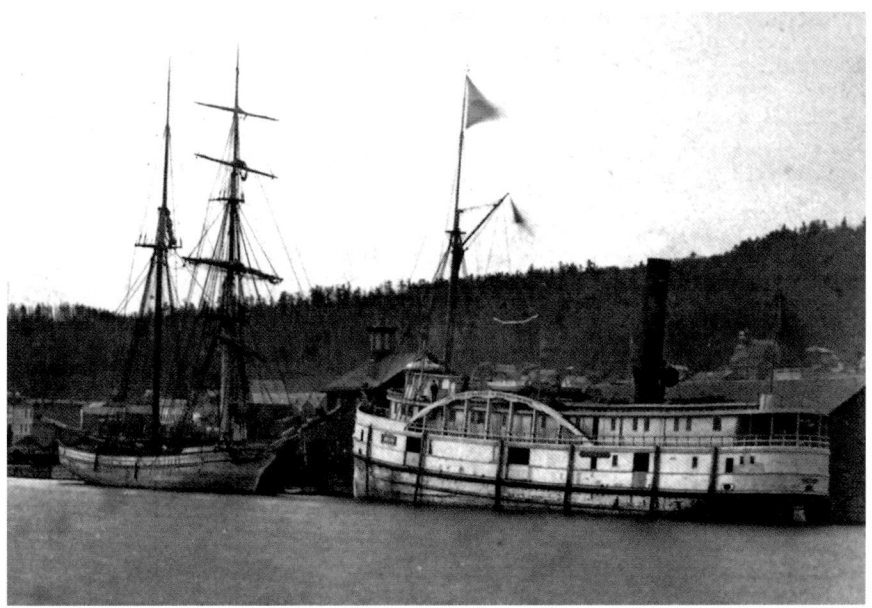

A schooner and steamer appear bow to bow, both destined for obsolescence. *Courtesy of the author.*

vanished. He was essentially a wild man. Civilization, in its most condensed expression, the steam engine, has driven him from the seas." So too, near the end of the twentieth century, observers could lament, "the age of passenger steamships on the Great Lakes is all but gone, no more the steam whistle to call travelers to an adventurous journey through the inland seas, no more the sight of majestic floating palaces, no more the grand conveyances that once glided over the deep blue waters and fought against their mighty waves. Transportation technology, in the form of ever better automobiles, highways and airliners, has consigned the passenger steamship of the Great Lakes to the pages of history."

CHAPTER 2

IMMIGRATION AND WESTWARD EXPANSION

Visions of the coming greatness and grandeur, and of the ultimate destiny of this continent, fill the mind with amazement. A wisdom above that of man has prepared for the inhabitants of worn-out, impoverished and over-burdened Europe, a fresh, fertile, primeval land, whose virgin soil and graceful forests will wave over millions of people.
—*Thurlow Weed, 1847*

The period between the arrival of the first passenger steamship on Lake Michigan and the start of the American Civil War, 1821 to 1861, was marked by rapid westward expansion. Drawn by the opening of government lands and encouraged by mass migrations westward, huge numbers of migrants from eastern states and immigrants from abroad moved to and through the states and territories bordering Lake Michigan.

By 1840, there were more than 100 steamers in service on the Great Lakes, a number of which were traveling to and from Lake Michigan ports. The passenger and merchandise businesses were booming, and settlers flowed into the area even though federally funded lighthouses and harbor improvements were still some years away. Many of these adventurous souls came by steamship; some traveling as cabin passengers, but many more took passage at the cheapest rates available as steerage or deck passengers.

On the upper deck of a steamer lived the cabin passengers, whose sumptuous appointments were carefully segregated from the deck passengers below.

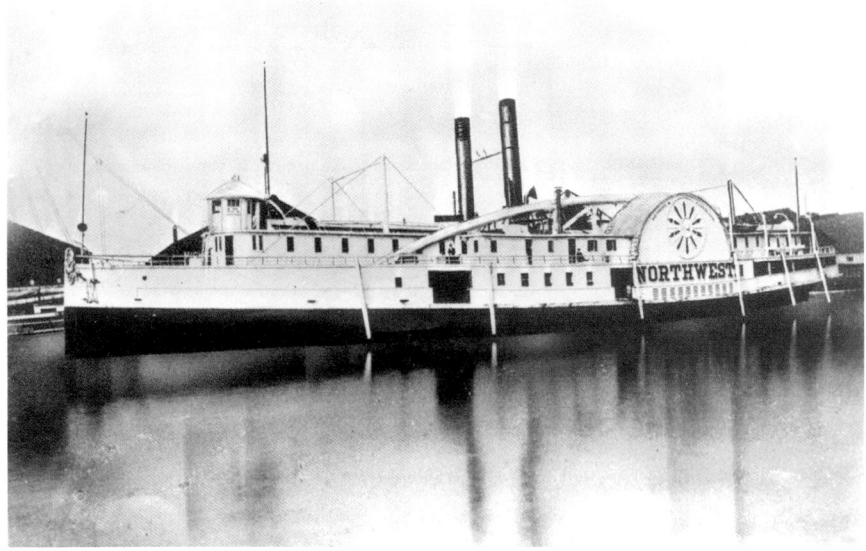

The 236-foot *North West* was typical of side-wheel steamers carrying immigrants across the lakes. *Courtesy of the author.*

> *The temporal finery of the cabins contrasted strongly with the minimal protection on the deck, where the best accommodation was to sleep on soft cargo that would not be disturbed. Deck passengers traveled cheaply and miserably for long distances and on occasion found themselves involuntarily assisting the wooding crew to load fuel for the steam engine.*[16]

During an 1847 trip from Buffalo to Chicago aboard the steamship *Empire*, Thurlow Weed described a wooding stop and the assistance of deck passengers. "At 8:30 o'clock this morning we came alongside a dock upon the shore, to wood. A hundred-and-six cords of wood (hickory, maple, beech and oak) were seized by the deck hands, steerage passengers, etc., and soon transferred from the dock to the boat, and at 12 o'clock we were under way. I learn that the *Empire*, in a single trip, consumes over 600 cords of wood. This requires for each trip the clearing up of over ten acres of well-wooded land. The wood which was taken on board to-day cost $1 per cord."[17]

The term *steerage* was used to describe the cheapest accommodations aboard steamships, which were characterized by being below decks with limited ventilation, scarce or nonexistent facilities and the presence of the

Immigration and Westward Expansion

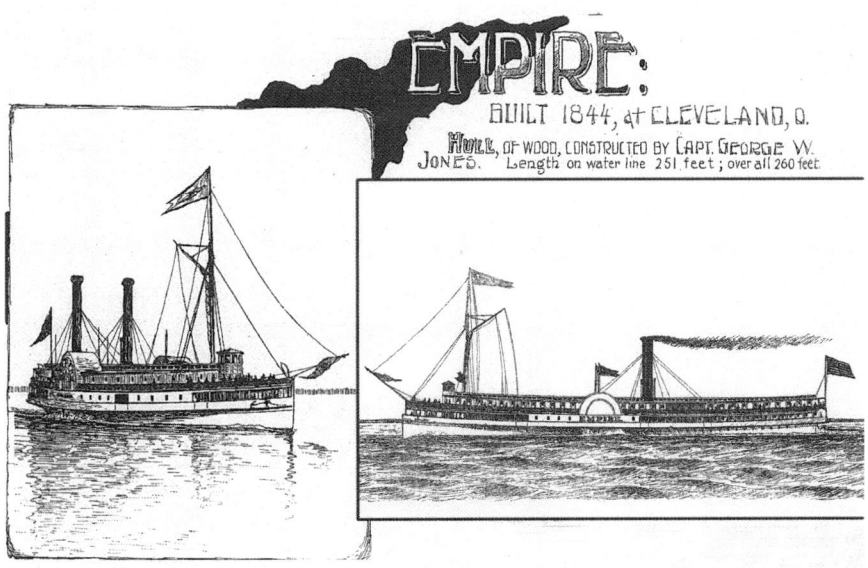

The steamer *Empire*, shown in this compilation of Samuel Ward Stanton illustrations, was built in 1844 for the Buffalo–Chicago route. *Courtesy of the author.*

steering mechanisms running through the ship to the rudder. On Great Lakes steamships, accommodations for steerage passengers were often on the decks of the vessels rather than the below decks areas; thus the term *deck* passengers came into usage, although the inaccurately descriptive term of *steerage* passengers remained in use as well.

Deck passengers were often crowded onto the steamships in such quantities that both comfort and safety were sacrificed by dangerous overcrowding.

> *The tide of immigration rolling westward often caused the transportation facilities of the time to be stretched much beyond the point of safety. Pioneers who came west on the passenger boats of the early* [eighteen] *fifties and before tell of passengers being packed so closely that it was almost impossible for the crew to do their work. Every boat bound up carried from three to five hundred passengers in the cabins and steerage, while many more than this was not at all unusual. Pioneers tell of going down to the piers at points on the west shore of Lake Michigan to see steamers which brought up 1,300 to 1,500 passengers.*[18]

In 1841, the cost of travel aboard a Great Lakes steamer from Buffalo, New York, to Milwaukee, Wisconsin, was $20 for a cabin passenger, and half that fare for a ticket in steerage. The cost for a traveling horse was $15, with the difference in accommodations between steerage and the horse stalls likely negligible. The $10 steerage ticket in 1841 would cost approximately $216 today.[19]

Captain Walker, a prominent steamship captain of the time, provided this insight into the development of steamer navigation on Lake Michigan:

From year to year emigration to Illinois and Wisconsin continued to increase, until a daily line of boats was established between Buffalo and Chicago, while at the same time the public demands were such as to require a still further advance, and a different class and style of boat with better accommodations and increased facilities, suited to the condition and circumstances of a large class of the more refined and wealthy, who were then emigrating and settling. And hence the necessity of introducing the upper-cabin boat. When the "Great Western" first made her appearance upon the lakes, and during the two years in which she was being built, many, who claimed to be judges, expressed doubts of the practicability and seaworthiness of that class of boats. But in a few trips she became a favorite with the public, and, notwithstanding the opinions and prejudices of a few, was the means of bringing about an entire revolution in the construction of our steam marine upon the lakes, causing all the boats in commission and contemporary with her, to convert their lower-cabins in steerages and freight-holds, and substitute the upper-cabin. It is proper here to say that the "Great Western" was built expressly for the upper-lake trade, and continued to make regular trips for ten successive years.[20]

Throughout the 1840s, those coming by way of steamer to communities along the shores of Lake Michigan included large numbers of Germans, Poles, Norwegians, Swedes, Swiss, Dutch, Finns, Irish, English, Canadians and more. The first immigrants to the region tended to settle in the southern parts of Wisconsin and Michigan and the northern reaches of Illinois, swelling the populations of those areas.

So great was the influx of humanity that the population of Michigan increased from 31,639 in 1830 to 397,654 in 1850. Likewise, Wisconsin's

Immigration and Westward Expansion

population increased from a mere 11,000 in 1836 to 305,391 in 1850, with one-third of the state's population foreign born. Meanwhile the city of Chicago, Illinois, possessed a population of just 4,470 in 1840, which ballooned to nearly 30,000 by 1850. The largest part of this great migration arrived by way of the lakes. In his 1899 *History of the Great Lakes*, J.B. Mansfield states:

> *In 1845 there were three daily lines of large steamboats leaving Buffalo for Toledo, Detroit and Lake Michigan, as far as Chicago. A careful count of the business done that year makes an aggregate of 93,367 through passengers, 5,369 passengers from way ports, total 98,736. Including other vessels about 200,000 persons, independent of the crews of the steamboats and vessels, crossed these upper lakes in 1845.*
>
> *By 1850 Wisconsin was peopled largely by a thrifty foreign population. It received its citizenship almost exclusively via the lakes, but was obliged to wait until Michigan had been at least partially settled, just as Michigan in time had to wait until the shores of Lake Erie had first been peopled by the emigrants.*

Throughout this period, midwestern communities, hungry for people and financial investment, worked actively to attract settlers from the eastern states and Europe. Pamphlets extolling the virtues of the area were published in German, Norwegian, Dutch and English and distributed in those countries as well as in eastern port cities. Advertisements were placed in more than 900 foreign and domestic newspapers during the years prior to 1855. Additionally, letters sent home by immigrants where often published in European newspapers. These first-hand accounts of the life to be had in the United States became known as America letters and were an important encouragement for continued immigration to North America in general and often to the Midwest in particular.[21]

The journey to new homes in the American Midwest was often one of considerable hardship, as evidenced by the accounts of those hardy individuals who endured so much for the chance of a better life. Sailing vessels of the period carrying migrants from Europe to North American ports usually made the crossing in six to nine weeks. However, adverse winds could cause these journeys to be extended to twelve weeks or more.

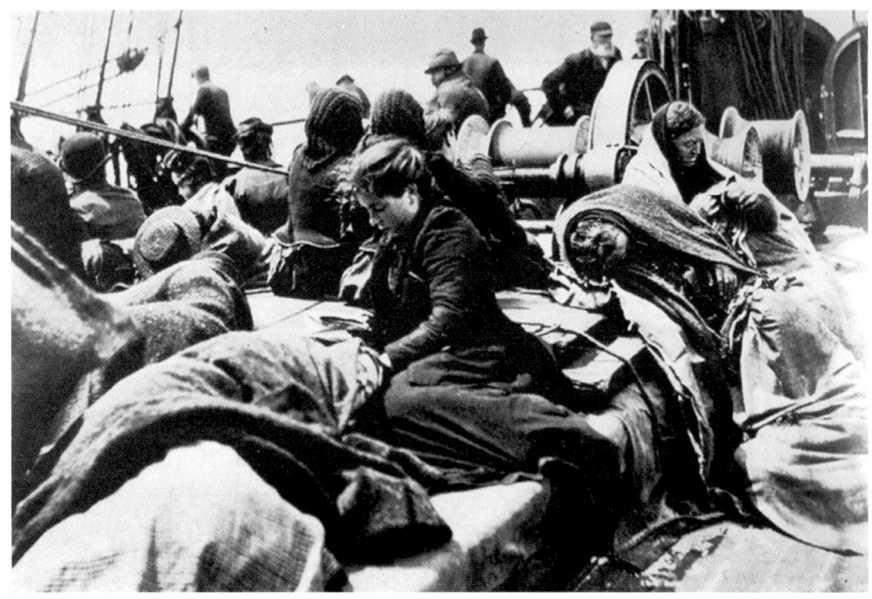

Immigrant deck passengers are seen aboard a steamer in 1893. *Courtesy of the Library of Congress.*

When a slow passage was encountered, passengers—who were responsible for supplying their own food and cooking utensils—would often run out of provisions. To avoid starvation, the ship's food supply would be tapped and fishing from the ship attempted. These efforts were often inadequate to make up the deficiency, causing hunger that sometimes verged on starvation. Additionally, fresh water would at times be in such short supply that extreme rationing was necessary. Such deprivations, when added to the cramped and often unclean conditions of these vessels, "caused much suffering and often sickness, and the unlucky passengers on such ships made a most wretched and pitiful sight when they arrived in port. An immigrant of the era wrote of the scene upon dropping anchor on arrival in North America:

> *When a ship arrived it would hardly have cast anchor, when men and women in rowboats would quickly be swarming around the vessel offering fresh wheat bread, buns, and other baker's goods, and fresh milk, butter, fish, and so forth, for sale. All of this was readily sold and gobbled up in short order. How the immigrants feasted and enjoyed the change from the everlasting dry and salt to fresh food was a caution.*

Immigration and Westward Expansion

In a letter written home to his brother in Norway, Ole Olson Østerud described his adventures while part of a group of Norwegian immigrants newly landed in Quebec and destined for Milwaukee in 1854:

> *No one was allowed to land before a doctor had come on board and examined us. He came at nine the morning of the third. We were then allowed to land, and at twelve o'clock on the third of June we stepped onto American soil for the first time. The first man we talked with after landing was Elias Stangeland, who is agent for a transportation line running inland. On this line the charge to Milwaukee was seven specie dollars, three marks, and eight shillings* [approximately nine dollars] *On another line the charge was one specie dollar more and seventy-five cents for each hundred pounds of baggage above one hundred pounds, which were carried free of charge.*[22]

A number of transportation companies were in competition for immigrant traffic coming into American and Canadian ports. During the season of 1854, twenty-eight Norwegian ships landed 5,488 people at Quebec alone. "During the whole season while the emigration office was open, a constant strife and persistent warfare went on between the agents and runners of the various lines." Further illustrating the nature of competition for the transport of immigrants is a letter written by Herman Haertel, the Wisconsin emigration commissioner, to "His Excellency, Leonard J. Farwell, Governor of the State of Wisconsin" in 1853:

> *The existing system of transportation, by the immense profit it yields, crushes all efforts to resist it, for the benefit of the deluded emigrant, and is supported by the favor and countenance of the state & city authorities themselves. The railroad companies & other transportation lines appoint regular agents to whom they give the inclusive privilege of selling their tickets to emigrants. Owing to the brisk competition of the said lines, those agents always keep in their pay a host of subagents, runners & tavern keepers who receive, besides a fixed salary proportioned to their skill & experience in business, a certain percentage for each & every ticket sold by them. It will easily be imagined that these persons use all means to get passengers for their line, that is, to pocket the percentage without caring the least for the honesty or dishonesty of the agent, or for the merits of the*

line in whose service they are. In the eyes of this class of business men the emigrant is but an article of trade which they try to buy as cheap, and to sell as high, as they possibly can do. The best lines and most honest companies are obliged to resort to the same means for attaining emigrant passengers; they differ, however, from those swindling agencies in one respect, viz. they never charge more than their advertised rates, and do not, as the others do, extort all the money they can from the poor emigrant.

The captains of emigrant ships, instead of landing their passengers at a public wharf, go & anchor in the middle of the river, and then sell the permission of boarding the vessel to the highest bidding agent and his army of runners. The emigrants & their luggage then are brought on board a river steamer, hired expressly for that purpose by the agent, and on their passage to the shore are induced by all tricks imaginable to buy "through tickets" to the place of their destination, before they tread on American soil. The more obstinate emigrants are led to a tavern keeper, who gets regular pay from the agent, and finally are prevailed upon by him to take passage on the same line. The greatest number of the emigrants are simple farmers and mechanics who, forgetting but too soon all the cautions received in the old country, fall victims to the impositions of those agents and their cohorts, who always know, in one way or another, how to get the confidence of their ignorant & guileless countrymen. It is no wonder, therefore, that so many cases occur every day, in which emigrants are forced to pay twice the passage price, or to take new tickets at Buffalo or some other intermediate station, and, besides that, must be satisfied with the worst mode of conveyance.

Once arrangements for passage inland were made, whether honest or not, immigrant groups were generally transferred without much delay to large river or canal steamers to continue their journey west. The fractured nature of transportation in nineteenth century America meant a number of transitions of both passengers and luggage from boat to train, to "large stagecoaches drawn by horses, thence to Buffalo by rail, and then on steamers over the Great Lakes to Milwaukee or Chicago."

Ole Olson Østerud explained further in his letter home to Norway:

On the sixth of June we boarded a large steamboat with two engines. There were some eight hundred people on this boat, but it would have been

Immigration and Westward Expansion

Steamer *State of New York* is seen at wharf with a list from a heavy load of passengers. *Courtesy of the author.*

>*permitted to carry fourteen hundred. There were Norwegians, Swedes, Irish, and German, black Negroes and brown Indians. We were comfortable while we were on the ocean compared with what we experienced going inland. There was always so much commotion, and there were so many transfers. And everything had to go in such a hurry as if life were at stake. If one were not on time, one would have to wait until the next day, which we surely learned in Chicago. When we had almost finished loading our baggage, the boat started, leaving several passengers, some of whose baggage was on the boat and some on the pier. They did not arrive in Milwaukee until the following day.*[23]

A number of immigrant letters from the period relate that passage from the East Coast to communities around Lake Michigan was often arranged in advance by the captain of the seagoing vessel that had transported the immigrants to North America. Unlike the captains described by Wisconsin's

emigration commissioner, many of these good-natured and honest captains acted out of a desire to help their countrymen avoid the misuse and swindling known to be prevalent among the agents of transportation companies.

Erik Thorstad, an immigrant arriving from Norway in August of 1852, described just such a case:

> *Our good leader, Captain Olsen, contracted with a company to carry us and our baggage to Milwaukee for $7 for each adult and half fare for the children. On August 14 our baggage was brought aboard a large steamboat and we left the evening of the same day at 5 o'clock.*

Captains, or other representatives of a group of immigrants, could contract with a transportation company, negotiating the cost per traveler and rates for baggage. "Among the passengers included in nearly every shipload were a few who had no means to pay their fare west. For these poor people provision was made by an agreement with the transportation companies, which carried them free on condition that the paying ones be sent over their line." Negotiations with the transportation companies also often included a provision that a "competent interpreter should go with each party to see that they were treated well and that the contract was properly fulfilled." It was reported that the job of interpreter for a large group of new immigrants—weary and bewildered by their new surroundings—was not an agreeable one, especially given the often-meager accommodations to be had as steerage passengers. "Very few cared to follow this occupation for any length of time."

While immigrants and other settlers from the east made up the bulk of travelers taking passage on steamers bound for Lake Michigan ports during the pre-Civil War years, there were other passengers as well, some of whom could afford the more amenable first-class passage. Unlike steerage, first-class accommodations on the steamers of the day ranged in quality from pleasant to opulent depending on the steamer chosen. Most of the first-class passengers were traveling for pleasure or business, although some were more well-to-do settlers headed west, or southerners taking the northern route east via Chicago. While not likely to mingle with their fellow travelers in the steerage class, these more-favored passengers were, nonetheless, willing to comment on them.

Immigration and Westward Expansion

> *On the lower deck are some dozens of German emigrants lately arrived from Faderland, as can plainly be seen by glancing at their quaint old Dutch costumes. The females of the party are solid, substantial-looking beings, with very rosy cheeks. They need neither paint nor cosmetics. Hanging to their skirts are a dozen or so chips off the old Dutch blocks, perfect resemblance to their sires.*[24]

> *The people on the boat were almost all New Englanders, seeking their fortunes. They had brought with them their habits of calculation, their cautious manners, their love of polemics. It grieved me to hear these immigrants who were to be the fathers of a new race, all, from the old man down to the little girl, talking not of what they should do, but of what they should get in the new scene. It was to them a prospect, not of the unfolding nobler energies, but of more ease, and larger accumulation.*[25]

> *German and Irish immigrants composed the greater number of the deck passengers. Exposed to the inclemencies of the weather many of these people were taken ill on almost every voyage.*[26]

> *A large number of people and goods of every description were now crowded together onto the steam boat. There were many people and all wanted to find a place to sleep. As many as found room went down below, but many had to prepare their beds upon the deck. The deck was crowded with every conceivable thing: baggage, new wagons, and much other stuff.*[27]

Immigrants new to the United States viewed their surroundings and the strangeness of American life with both wonder and anxiety.

> *When one arrives and comes out upon the street, and does not know which way to turn, and besides cannot speak with people, then one is likely to wish he were back home, and that he never had seen America.*[28]

> *I had never seen a locomotive or a steamship in my fatherland, and was filled with wonder at the steamers in the harbor.*[29]

Immigrant deck passengers are seen aboard a steamer. *Courtesy of the Library of Congress.*

I am getting along in every way as well as one could wish, considering that I am in a strange land, and among strange people, and a strange language, for I can not get these cussed Yankees to speak Norwegian, I therefore have to jabber English all day long, it is far from being of the best, but that makes no difference, because they are used to broken English. My word! How the English language is mutilated here, Frenchmen and Italians especially deal with it in a barbarous manner.[30]

As seen from the deck of a steamboat, the forests which grace the land were so even that one was tempted to believe that all the trees grew to a definite height, above which they were unable to reach....There is activity everywhere, both on land and water. The steamboats with their star-spangled flags and long smoke streamers whiz past each other, filled with well-dressed and attractive looking people. The sound of music of horns and other instruments comes from them over the water. Schooners, sloops,

Immigration and Westward Expansion

and numerous smaller vessels skim about like flies on the broad surface of water. All this is so grand, so beautiful, that anyone who enjoys living must be glad and cheerful.[31]

Unfortunately steamship travel across the Great Lakes was not without risk and was in fact quite hazardous in this period. The lakes were known for their tumultuous weather in all seasons. Beyond the risk of foundering in a storm, there were also the threats of fire, collision, sickness and boiler explosions.

The summer of 1852 held an especially full record of accidents on the lakes, including the burning of the *Henry Clay* with a loss of at least fifty-eight people; two steamship boiler explosions that killed forty-three and injured many more; and the tragic loss of the passenger steamer *Atlantic*, heavily loaded with immigrants bound for Milwaukee and other Lake Michigan ports.

It is very likely this series of events that Herman Haertel, the Wisconsin emigration commissioner, was referring to in 1853 when he wrote:

Great aversion seems to exist among most of the emigrants against the passage round the lakes, partly owing to the frequent steamboat accidents recently occurred on these lakes, of which they are generally well informed, and partly arising from the disgust against another voyage.

It is no surprise that new immigrants would be well aware of steamship disasters on the Great Lakes, especially those which had led to the deaths of travelers such as themselves. No news spreads more quickly than that of disaster, and the papers of the day were always quick to headline such events. The *New York Daily Times* reacted to the August 20 sinking of the *Atlantic* with the headlines, "The Catastrophe on Lake Erie.; FURTHER PARTICULARS. NAMES OF THE LOST AND SAVED. Incidents–Meeting of the Survivors, &c., &c. By Telegraph to the *New-York Daily Times*. Coroner's Investigation."

The steamer *Atlantic* was a side-wheel steamship built in 1848 that regularly ran a route between Buffalo, New York, and Detroit, Michigan. At the time of her loss, she held the record for fastest passage between the two ports, with a time of sixteen-and-one-half hours. The *Atlantic* was designed to carry passengers and freight; on the night of the collision she was

This compilation of Samuel Ward Stanton illustrations shows the steamer *Atlantic*, which was lost in a collision with the propeller *Ogdensburg*, on August 20, 1852. *Courtesy of the author.*

heavily loaded with over 500 passengers, mostly German and Norwegian immigrants bound for communities in Michigan, Illinois and Wisconsin. The *Atlantic* was struck by the propeller steamship *Ogdensburg*, a rival on the route, between one and two o'clock in the morning of August 20, 1852. The collision caused considerable damage to the *Atlantic*, which led to her eventual sinking. However, much of the terrible loss of life was caused by panic and confusion, not the final foundering of the ship. At the time of the collision, a dense fog was prevailing and the first mate was in charge of the *Atlantic*. The passengers were asleep with many filling walkways and other spaces throughout the crowded boat. Immediately following the collision "the outmost confusion prevailed among the deck and steerage passengers." Many of them, in their terror, jumped overboard instantly. A Boston publication reported:

> *Capt Petty vainly endeavored to calm their fears, by assuring them there was no danger, hoping to keep the steamer on its course, and reach port in season to save them. The emigrants, who could not understand a word spoken to them, added horror to the scene by their cries and exhibition of frantic terror. Great numbers of the immigrants jumped overboard in their terror, without any provision for their safety, and thus rushed on to certain death.*

Immigration and Westward Expansion

The *New York Daily Times* also reported the gallant efforts of the *Atlantic's* crew:

> The coolness of the officers had a striking effect upon the majority of the cabin passengers; and all who could understand their words of soothing and encouragement, availed themselves of the stools, which were furnished with life-preservers, and other articles of furniture, and as the water gradually arose, ascended to the hurricane deck, where they were mostly picked off safe.
>
> But the poor emigrants, who could not understand one word of what was said by the officers, being waked from their slumbers by the shock of the collision and the succeeding rush of waters, were panic-struck, and threw themselves, without the least preparation, into the lake, where so many of them perished. Probably many were drowned in the hold of the steamer, unable to reach the companion way.

Amund O. Eidsmoe, one of the Norwegian immigrants aboard the *Atlantic*, gave this account, which was much less flattering in regard to the actions of the crew than the versions of events presented by the newspapers:

> We were awakened by a loud crash and saw a large beam fall down upon a Norwegian woman of our company. It crushed several bones and completely tore the head off a little baby that lay at her side. Another ship had collided with ours and knocked a large hole in the side of the "Atlantic" so that a flood of water rushed into the cabins and people came up as thick and fast as they could crowd themselves. It seemed as if even the wrath of the Almighty had a hand in the destruction.
>
> The sailors became absolutely raving and tried to get as many killed as possible. When they saw that people crowded up [from steerage] they struck them on the heads and shoulders to drive them down again. When this did not help, they took and raised the stairway up on end so the people fell down backwards again. Then they jerked the ladder up on the deck. All hopes were gone for those that were underneath. Water filled the rooms and life was no more.
>
> People rushed frantically from one end of the boat to the other. The trap doors were torn open and goods and people were swept into the water. Then

was the life of a person of little value. My wife and children and I were miraculously saved; although swept into the water as the ship sank, with much swimming around with my wife and children on my back, we were picked up by the other ship. When I discovered that all of my family were alive, I was full of joy, as if I had become the richest man in the world, despite the fact that we had lost all of our goods. We had lost all but our lives, but they were precious, we now realized.

On August 24, 1852, the *New York Daily Times* carried the following testament made by a cabin passenger who had been aboard the *Atlantic* during the disaster:

All was confusion, and the next moment the command was given, in a very stifled and agitated voice, to head her in for shore, and ring the bell, both of which command were soon obeyed, and some exertions were made to careen her over on the starboard side, to keep the water from rushing in, but without much effect. All this time her engine was in motion, as it had been all the while, and we were fast leaving the propeller.

I then thought it time to make an effort to save my life. I made for the door of the saloon in order to reach the main deck. I found it dark there, and not a light to be seen, and I do not believe there was one on that part of the boat; however, I succeeded in getting down, and tried to find something to float upon. I secured the after gangway door. I placed it over the rails on the guards outside, intending it for future use, concluding to remain upon the wreck as long as I could, giving myself sufficient time to clear the vessel when she should go down. But very soon the cry of "fire" was heard, at which time the emigrants were jumping off the forward deck, as they had been doing previously, by dozens; some sinking under the wheels, and some passing astern, uttering such fearful cries for help, in their own language, as to render the scene, which it is impossible to describe, doubly appalling.

Some fifteen or twenty minutes after the collision, the main deck sunk; and then I launched my frail support, and struck out to clear the vortex which I suppose would soon be made by the sinking vessel.

Survivor Walter Osborn, Esq., wrote the following description of the loss of the steamer *Atlantic* while onboard the steamer *May Flower* on August 21, 1852:

Immigration and Westward Expansion

I at length found the forward cabin door; the cries and screams now proceeding from every part of the boat—which were made more horrible by the intense darkness in which we were enveloped. I forced open the door, and to my surprise and horror, I found the boat was rapidly sinking. After several attempts, I succeeded in climbing one of the forward stanchions which supported the promenade deck, which I had no sooner gained than I found the whole of the forward part of the vessel had already filled, and that the water covered the whole lower deck. I hastened aft, and to my grief and astonishment I found the rush of water had been so sudden as to drown all in the main cabin, except one baby and the maid, who were both saved. At the last moment, some one caught them, and drew them to the upper deck. So suddenly had the host settled that nearly all the ladies and gentlemen who succeeded in reaching the hurricane deck were in their night clothes.

The boat now lay at an angle of about 20°, the water covering the hurricane deck some distance abaft the chimneys. It was perhaps 3 o'clock—the uncertainty of the propeller coming to our rescue—150 of us crowded together in a small space on the hurricane deck—the shrieks of the drowning on each side of us, with an occasional cry of 'God save us!' or 'God have mercy—I am sinking!' made a scene you cannot imagine, nor I describe. Scores of unfortunate beings were perishing, and none could help. Where I stood, were husbands with their wives, some of whom had little ones clinging to them, awaiting the dreadful moment when they should sink into their watery graves in each other's embrace.

The propeller *Ogdensburg*, not badly damaged, caught up with the *Atlantic* after an hour's separation, by which time the vessel was deeply awash throughout her forward works with only the stern and masts still above the water. The crew of the *Ogdensburg* lowered boats and "did all in their power to preserve the lives of the hundreds of human beings who were now seen struggling in the water."

As many as 150 cabin passengers were still crowded at the stern of the sinking vessel and were taken off by the *Ogdensburg* without ever touching the water. Others who had clung to ropes amid the masts were also taken off safely. Several newspapers reported the fate of a small boy of about eight years of age—orphaned by the disaster—who was among those clinging to

the ropes and was saved when men near him took him in their arms when he had grown too weary to hold on any longer.

In all, it is believed that over 300 passengers and crew were drowned, most of the victims having been among the many immigrants aboard. Following the disaster, public outcry for government regulation of steamships led to the passage on August 30, 1852, of a bill in Congress providing for the licensing and inspection of steamboats. The bill included requirements for carrying life boats and life preservers as well as regulations regarding boiler pressures and other safeguards.

Chapter 3

The Passenger Experience

For the first time, from the upper deck, I saw one of the great steamboats come majestically up. It was glowing with lights, looking many-eyed and sagacious; in its heavy motion it seemed a dowager queen, and this motion, with its solemn pulse, and determined sweep, becomes these smooth waters.
—Margaret Fuller, 1843

The experience of traveling on or to Lake Michigan by passenger steamship likely had as many variations as the millions of people—immigrants, settlers, leisure travelers, day tourists and businessmen—who did the traveling. Certainly the type of steamship traveled on, the year of travel and the type of accommodation secured would all make a great deal of difference to the sort of experience the traveler enjoyed or endured. Additionally, other external factors such as crowding, mishaps, weather or the temperament of traveling companions could all influence the character of one's trip.

During the 1820s and 1830s—the earliest years of steamship travel on Lake Michigan—the steamers on the lake were relatively few and all were side-wheel paddle-wheelers intended for the dual purposes of carrying passengers and freight. Freight could take many forms: pickled fish, furs, skins, sugar, country produce, peltries, merchandise, domestic manufactures, shingles and even livestock. "She is tolerably well laden with freight, also horses, besides a goodly number of cabin and deck passengers," wrote Lansing B. Swan while aboard the steamship *Madison*

Passengers await the arrival of a side-wheel passenger steamer. *Courtesy of the author.*

on June 9, 1841.[32] Another steamer record of the period showed the vessel laden with a cargo of "fish, feathers and Indian mats," as well as passengers.

In March of 1830, Frances Trollop, a cabin passenger, recorded her impression of travel by Great Lakes passenger steamship:

> *We got on board the steam-boat which was to convey us at three o'clock. She was a noble boat, by far the finest we had seen. The cabins were above, and the deck passengers, as they are called, were accommodated below. In front of the ladies' cabin was an ample balcony, sheltered by an awning; chairs and sofas were placed there, and even at that early season, nearly all the female passengers passed the whole day there.*

Throughout this period, stagecoach lines to and through the Midwest were in heavy use; however, the roads that were available were marginal at best. Railroads were still limited in their lines and destinations, making steamship passage from Buffalo to Chicago, Milwaukee, Green Bay or other communities on the western shore of Lake Michigan a primary transportation resource. Among the advantages of travel by steamship was

The Passenger Experience

the matter of comfort: early trains and stagecoaches could not boast the ease, hotel-like accommodations and comfort of a steamship journey.

> *May 31, 1828—Several persons well acquainted with the road gave such discouraging accounts of it that, tired as we were with the jolting we had experienced* [by stage] *and our bones still aching, we had little mind to encounter such another journey. We next walked down to the wharf to learn what steamboats were going.*[33]

To book passage on a steamship, a traveler would present themselves at the office of the agent for the particular steamship or steamship line or simply go aboard the steamer when it was at dock—being loaded or unloaded—and enquire about passage with the ship's purser. The purser's office on the steamship was generally fitted with a ticket window not unlike that at a theatre. Reservations for travel on a particular date were also accepted by mail provided a deposit was made. In 1863, the steamer *Planet*, with Captain L. Chamberlin, running out of Chicago, advertised:

A steamship's interior stairs to the upper decks are at left, and the purser's office is to the right in this photo, circa 1900. *Courtesy of the author.*

Passengers will please purchase their tickets on board the boats. First Class includes Meals and Berths. For Freight or Passage, apply on board, or to A.E. GOODRICH, 6 and 8 River Street, Chicago.

The schedules of steamships in the first decades of steamer travel on Lake Michigan were, by necessity, approximate by day rather than hour. Later, with improvements in harbors, rivers, dredging and the steamships themselves, the schedules became more regular, although weather or mechanical failures were still known to disrupt sailing schedules. "Sailing is expected on the days and times scheduled, but all sailings are subject to unavoidable change."[34] The cost of tickets was determined by level of accommodation, with the choices being cabin or deck passage and additional amenities, such as meals. Some lines advertised half-price tickets for "servants, and children over three and under twelve years old." Meals and berths were often included in the cabin or first-class ticket price.

In 1846, Thomas Horton James, an English traveler touring the United States and Canada, gave the following assessment of the costs of travel on the lakes:

Travelling in America is just as cheap as stopping. As the people are all, more or less, anti-renters, they live in boarding houses, and as soon as they leave the expense ceases, and they begin boarding in a steamboat instead of

BAY SHORE ROUTE.
For Pensaukee, Oconto, Peshtigo, Marinette, and Sturgeon Bay.
The Steamer Queen City,
Captain J. A. MONROE,
Will run until further notice between Green Bay and the above-named Ports, leaving Green Bay on Monday, Wednesday, and Friday Mornings, at 7½ o'clock, and Marinette Tuesday, Thursday, and Saturday Mornings, at 6 o'clock. Will run into STURGEON BAY on her down trip every Friday.
JOHN B. JACOBS.
For Freight or Passage, apply on board, or to
STRONG & DAY, Agents, Green Bay.
GREEN BAY, *March* 31, 1863.

A newspaper advertisement announces the schedule for the steamer *Queen City* out of Green Bay in 1863. *Courtesy of the author.*

The Passenger Experience

on shore. For instance, the steamers at Buffalo, the best of them, go twice a day to Chicago, 1,050 miles up the lakes, offering three meals a day, good substantial meals, and an excellent roomy cabin to yourself to sleep in, besides a splendid saloon and promenade. This for less than one halfpenny per mile, board and lodging included! And as the voyage occupies five days, the total expense is less per day in a steamer, more like a ship of the line than our English steamers, than hotel lodging.

Passenger entry onto the steamers was provided via rope-railed gangplanks rising from the dock through large doors in the side of the vessel called *gangways*. Cattle, horses and freight were also brought in thorough gangways to other portions of the ship. "On going aboard ship the passenger must show to the officer at the gangway a transportation ticket, together with berth check, if he has already procured same." Upon passing the gangway officer, passengers could generally expect to find a foyer, with the purser's office close at hand, and a steward anxious to see them safely settled. "Proceed to the purser's office, where the ticket will be exchanged for a purser's check." Generally a stairway, often quite grand, led upward from this area to the decks and compartments above. Within the ship, and on the dock outside,

Passengers and luggage going aboard a Great Lakes steamer. *Courtesy of the Library of Congress and Detroit Publishing Co.*

people would be moving about in anticipation of departure. S.M. Fuller described just such a scene in the summer of 1843, "Baggage coming on board—Passengers bustling for their berths—Little boys persecuting everybody with their newspapers and pamphlets, my friends huddled up in a forlorn corner, behind a large trunk—A heavy rain falling."[35]

> *1845. We had nearly a dozen boys on board, with great bundles under their arms, singing out, "Last Lecture of Mrs. Caudle" only one halfpenny; No. 20 of the "Wandering Jew," and all Bulwer's and James's novels, at a shilling each! The boys drive a very lucrative trade in these amusing wares; one youth told me that he cleared ten dollars a-week on a capital of only ten dollars! He could therefore dress well, smoke all day, talk politics and literature, and have a glass of gin-sling when he liked! These American boys begin the world with about five dollars' worth of cheap publications and travelling-maps.*[36]

Luggage was dealt with by the policies of each steamer. One such policy stated: "All baggage, except hand baggage, is checked and is easily attainable. By showing their checks to the porter, passengers can have access to their trunks at stated hours. One hundred and fifty pounds of baggage, consisting of wearing apparel only, carried free on each full-fare ticket; seventy-five pounds on each half-fare ticket. Hand baggage and steamer trunks, not exceeding fifteen inches in height, may be taken to parlor and state rooms." Once freed of their luggage and the press of boarding, first-class passengers were treated to saloons and dining areas aboard the steamships that were almost invariably spacious and ornate—and in the era of palace steamers, 1844 to 1857, positively grand—with lavish decorations and luxurious furnishings. "The boat and its accommodations are of the same description of magnificence as in all the other much vaunted boats in these waters."[37]

> *Steamboat* Empire, *June 30, 1847—I am afloat for the first time in that magnificent steamer, the* Empire. *In ascending to her beautiful saloon we found some three hundred ladies and gentlemen grouped around upon sofas, divans, etc., as luxuriously as on board of our own splendid* Isaac Newton *and* Hendrick Hudson.[38]

The Passenger Experience

While the accommodations for deck passengers were certainly less overawing, the ships themselves were nonetheless a grand conveyance for all aboard. "Our steamer was full to overflowing with travellers of every rank, age, sex, and condition of life, who were all bound to the Eldorado of the west to seek new homes and new employment."[39] A commonality between the classes of passengers was a desire for entertainment, in part brought on by the holiday air present aboard the steamers from the opening to the close of navigation. Steamships frequently carried musicians, with one advertisement claiming, "During the months of July and August on these trips will be good BRASS AND STRING BANDS, and every effort will be made to secure the comfort and convenience of passengers."

July 1, 1847—We have a calm, delightful night. This evening, soon after tea, the saloon was arranged for dancing and the hours were passed very

Passengers aboard a steamer participate in a deck game, circa 1900. *Courtesy of the City of Vancouver Archives.*

pleasantly in conversation and in the mazes of the cotillion and the whirlings of the waltz. And here, let me say a word about the mode of "killing time". I had heard much about gambling on the lakes. But if this habit continues, the Empire's *passengers form an exception to the rule. The time, so far, has been most rationally appropriated. Many volumes of 'cheap literature' have been devoured. Lakes, harbors and river improvements have been freely discussed. But cards seem to have gone out of fashion.*

Time has passed very pleasantly upon the St. Louis *since we left Chicago. Though the number of passengers was too large for a pleasure excursion, yet the efforts of the officers to accommodate and please, and the disposition of passengers, generally, to be pleased, has been successful. The passengers breakfast, as at the Astor House, whenever they please, between the hours of 7 and 11 A.M. There is a lunch at 12. At half-past 2 we dine. A substantial tea is served at 7; and at 10 the supper-table is spread. And the fare is not only uniformly abundant, but the cooking excellent. The table is loaded with meats, viands, delicacies, etc., all served in good*

The grand saloon of passenger steamer *Puritan* is seen in 1896. *Courtesy of the Library of Congress.*

The Passenger Experience

> taste. *Our evenings are uniformly gay and joyous. Immediately after tea, the tables are removed from the saloon, the band appears and 'the ball opens.' Dancing commences at 8 and continues till 11 o'clock, with much spirit, not only by the young ladies and gentlemen, but by many of the elder and graver personages, to whom the occasion has brought back something of the freshness and inspiration of youth.*[10]

> *The tables had been rolled away, and the colored waiters, with their guitars and banjos, formed a vocal and instrumental band. These lake minstrels sang in their melodious voices. The floor was crowded with dancers, all formality was laid aside, strangers danced with strangers, and even that relic of the past, the slow waltz, had its devotees. A Virginia reel brought us close upon Sunday morning, and we all retired.*[11]

From the mid-1840s onward, there were a great many steamers regularly operating a variety of routes on Lake Michigan, including short trips between cities along the coasts, cross-lake runs out of Milwaukee, day trips on the lakes to scenic spots, small mosquito steamers serving smaller ports and islands and longer cruises the length of the lake to and from Mackinaw, Detroit and points east. The population aboard most steamers was made up of people fitting nearly every description and traveling for a wide variety of reasons. New immigrants and other settlers headed west; area residents traveled from port to port for pleasure or business; other folks, including southerners taking the northern route through Chicago, traveled east; and a great deal of freight of every description moved from place to place. Settlers eager for a new life rubbed elbows with pleasure seekers, itinerate businessmen, missionaries, government agents and every other sort of traveler, creating a colorful democracy of shipboard companions.

> *During the daytime, the gaudy but commodious cabin presented a curious sight. At the after part of the saloon, which is styled the ladies' cabin, sat groups of "muchly" crinolined farmers' wives and daughters, frowsy dowagers, and laughing maidens. Some ladies sat singly (doubtless old maids), who rocked their chairs in a very melancholy manner, or appeared absorbed in some novel. At the gentleman's end was a motley assemblage of characters—divines, dominies, philanthropists, misanthropists, innocent*

youth, old sinners, ubiquitous "drummers," or commercial travelers. All seem to be dragging a miserable existence, and constantly smoking, or indulging in agonizing yawns. With their feet elevated to the level and altitude of their heads, these unfortunates contrive to pass the intervals between meals.[12]

1845. There is a bar for the sale of fruit and drinks and very often may be seen three or four well-dressed itinerant merchants, who, in the true spirit of American enterprise, as they are going a journey of business, begin at the beginning, and, whether it be umbrellas, type for marking linen, &c., they manage to do a little trade, and pay their current expenses by selling their respective wares amongst the passengers.[13]

1867. Commercial travelers are the omnipresent agents for everything under the sun, from the newly invented shawl pin to the pill that cures every mortal disease in one-twentieth part of a second, and from the lately patented, self-acting tweezer, to the magic double-performing, self-adjusting, anti-freezing force pump, which has been pronounced the "greatest wonder" of the nineteenth century.[14]

1847. Of our party, which numbers about two hundred, nearly one-third are ladies—agreeable and accomplished ladies, whose conversation, music, and accomplishments invest the excursion with an interest which ladies only can impart to society, and without which it would have been robbed of half its enjoyment.[15]

We were disturbed by the dressing bell at half past four this morning and to try to sleep longer was in vain for the passengers began walking and clattering like the hens and geese in a poultry yard roused by the first crowing of the cock. To be sure it was two hours and a half before we got breakfast and then not a drop of milk was there to be had.[46]

Sept. 27. 1841—One of the first peculiarities that must strike a foreigner in the United States is the deference paid universally to the sex, without regard to station. Women may travel alone here in stage-coaches, steamboats, and railways, with less risk of encountering disagreeable behaviour,

The Passenger Experience

Passengers are seen on a small steamer. *Courtesy of the Library of Congress.*

and of hearing coarse and unpleasant conversation, than in any country I have ever visited.[17]

No man sat down until the ladies were seated; or omitted any little act of politeness which could contribute to their comfort. Nor did I ever once, on any occasion, anywhere, during my rambles in America, see a woman exposed to the slightest act of rudeness, incivility, or even inattention.[18]

June 25th, 1841. At the breakfast table I met with one or two good looking ladies, which was really pleasant, as I really believe I have not seen a half dozen decent looking women (I mean so far as features are concerned) since I left home. The Michigan women, for I cannot write them down ladies, are in looks, the ugliest I have ever seen.[19]

1845. We had but few passengers, not above thirty, in a saloon fit to accommodate a hundred. But this proved rather an advantage. The passengers became all very sociable together, which could not have been the case had we been full; and as the weather was fine, and our table abundant, we did not affect an impatience which we did not feel.[50]

Passengers enjoy the air aboard a Great Lakes steamer. *Courtesy of the author.*

It was very pleasant coming up. These large and elegant boats are so well arranged that every excursion may be a party of pleasure. There are many fair shows to see on the lake and its shores, almost always new and agreeable persons on board, pretty children playing about, ladies singing, (and if not very well, there is room to keep out of the way.) You may see a great deal here of Life, in the London sense, if you know a few people; or if you do not, and have the tact to look about you without seeming to stare.[51]

1836—In fine warm weather, more especially during your first voyage, both curiosity and comfort will lead you to spend by far the greater part of

The Passenger Experience

your time in the open air; where the gentle breeze, freshened by the rapid motion of the boat, will always cheer you, while with conversation and reading you while away the monotonous hours of a long morning....It is possible that you may meet with a few well-bred, intelligent travellers that you may be both in good health and good humour—that the general run of the voyage may be prosperous and without accidents or detention.... But you may chance to fare otherwise, and for the sake of illustration we will suppose that the very contrary is the case in almost every particular; that heated in body and mind by confinement and disappointment, you are peevish as a peahen; that the society is decidedly ill-bred and vicious that the boat jars so with every stroke of the piston that you cannot write a line-further that you have no books, the cabin is crowded—the machinery wants constant repair—the boilers want scraping. The pilot is found to be a toper—the engineer an ignoramus—the steward an economist—the captain a gambler—the black firemen insurgent, and the deck passengers riotous. Instead of accomplished females, such as at another time you might have as fellow-passengers, we will suppose the ladies' cabin to be

A passenger steamer's dining room is seen in 1896 in a photograph by Rand, McNally & Co. *Courtesy of the Library of Congress.*

tenanted by a few grotesque, shy, uninteresting beings, never seen but when marshalled in by the steward to their silent and hurried repast, and never heard, but, when shut up in their own apartment, a few sounds occasionally escape through the orifice of the stove-pipe, making up in strength for what they want in sweetness. What are you to do in such cases? You may lounge in the antechamber, and watch the progress of stimulating at the bar—you may re-enter the cabin and strive to get possession of a chair and a gleam from the stove. For the rest, you may study human nature in many forms, and one thing will not fail to strike you, and that is the marvellous rapidity with which the meals follow, and the world of important preparation which passes before your eyes for an end so little worthy of it.[52]

Breakfast

The table is spread with substantials, both in profusion and variety; and considerable impatience is generally observable to secure places, as it

A passenger steamer's galley is seen in 1896. *Courtesy of the Library of Congress.*

The Passenger Experience

frequently happens that the number of cabin passengers is greater than can be seated with comfort at the table, however spacious.

The Steward, or his assistant, after many a considerate glance at his preparations, to see that all is right, goes to the ladies' cabin, and announces breakfast, an announcement which is generally followed by their appearance. They take their places at the upper end of the table, and then, and not till then, the bell gives notice that individuals of the rougher sex may seat themselves.[53]

At breakfast, this morning, the trout taken yesterday in Carp River were served. They were done to a turn; and larded, as they were, with delicate slices of salted pork broiled to a crisp, I need not say that the repast was a delightful one.[54]

Had a tolerable night's rest and did not get up until about 7:00, consequently breakfast was on the table as soon as I could get dressed. My stateroom opening into the cabin, I stepped out and took a seat at the table. Coffee bad, it could no doubt be improved by having the compound contain more coffee and less peas.[55]

LUNCH

The steamboat is a great floating hotel, of which the captain is landlord. He presides at meals, taking care that no gentlemen take their places at table till all the ladies, or, as we should say in England, the women of every class, are first seated. The men, by whom they are accompanied, are then invited to join them, after which, at the sound of a bell, the bachelors and married men travelling en garcon pour into the saloon, in much the same style as members of the House of Commons rush into the Upper House to hear a speech from the throne.[56]

At the head of the long table at meal time sat the middle-aged, florid-faced captain. His office appeared to be to escort the old ladies to the table, and to smile condescendingly on the young misses. In our ignorance we committed an unpardonable breach of etiquette by sitting down simultaneously with

The dining saloon of the steamer *Olympia* had seating for 500. *Courtesy of the author.*

the captain. The waiters were excessively indignant, and looked horrified, and in more ways than one showed that their tender 'feelin's' had been outraged. After the captain and ladies had sat down, the autocratic steward rang a second bell, and with a majestic wave of the hand, and a calm, benignant smile signified his pleasure that we should sit down.[57]

Dinner

In these moving palaces, we sat down two hundred to dinner, and an excellent dinner we had, but it was two shillings each, rather a high price. I noticed that everybody drank water. I hardly remember one single cork being drawn during the whole dinner; perhaps there was not one! Now here is a fact as truly astounding as the vast proportions and magnificent fittings of the steamer, and I thought to myself, who can stop the progress of a nation that to an unlimited extent of fertile land adds these two grand auxiliaries of steam and temperance?[58]

The meal I leave to your lively imagination to picture.... You might imagine that the beings engaged in it were for the time, part of the engine, which is sighing and working underneath at the rate of one hundred strokes in the minute, so little does their occupation admit of interruption. There is little or no conversation, excepting of the monosyllabic and ejaculatory kind

The Passenger Experience

> which is absolutely necessary; and instead of the social hour, during which in other lands, the feast of the body is often found to be compatible with the feast of the soul—you spend, in fact, an uneasy ten minutes, in which the necessary act of eating is certainly stript of all the graces.... There is no quarter given.[59]
>
> There is no doubt that the meal was disposed of somewhat ravenously; and that the gentlemen thrust the broad-bladed knives and the two-pronged forks further down their throats than I ever saw the same weapons go before, except in the hands of a skilful juggler....As each gentleman got through his own personal amount of tea, coffee, bread, butter, salmon, shad, liver, steak, potatoes, pickles, ham, chops, black-puddings, and sausages, he rose up and walked off.[60]
>
> Many of the males will leave the table the moment they are satisfied—the ladies leave it as soon as they well can; and then in come the barkeepers, engineers, carpenter, pilot, and inferior officers of the boat: the table again groans with its load of plenty, and is again stripped and forsaken, to be a third time the scene of feasting for the black steward and coloured servants of both sexes. During these latter scenes of the same act of the same play, I need hardly press you to quit the cabin for the seats on the boilerdeck, or, still better, for the hurricane-deck above.[61]
>
> At the first welcome sound of the bell, all unite in a grand rush to the table, gorge themselves with two dozen different viands, from fish, fowl, flesh, to pudding, cake and molasses, in ten minutes and five seconds they will be found around the stove, smoking away as energetically as ever. At night they stretch their dyspeptic bodies in two tiers the whole length of the cabin, and thus the passengers pass their days on board.[62]

Not all was dining, dancing and merriment aboard the steamers in the nineteenth century. Cruises that took a period of days often found travelers on the lake on a Sunday, and church services aboard were not uncommon.

> At 10 o'clock today our steamer's bell was tolled for the purpose of assembling the passengers in the saloon for divine service. The Rev. Mr.

Stimpson, of Greenbush, officiated. The services were impressive—the audience large and attentive. During the services a bird 'on weary wing' flew into the saloon, hovered around among the congregation, and then passed out to find a resting place upon the shoals. We have now been nearly four days 'at sea' and everything has gone just right. The steamer is well managed. Though nearly three hundred passengers draw around the table, the fare continues as abundant and extensive as it could be if Fulton Market was at hand every morning.[63]

While divine services were held aboard ship on Sundays, it is safe to assume that a great many more prayers were lifted heavenward whenever a passenger steamship encountered one of Lake Michigan's notorious, and not infrequent, storms. "The clouds became gradually as black as night, and constantly gave out such vivid lightning, accompanied with astounding claps of thunder, that it appeared almost certain to many of us that the steamer would be struck." These and similar sentiments are echoed in a hundred remembrances of travel on Lake Michigan. Lightening, fog, wind, waves,

Crew from the railroad car ferry *Sainte Marie* examine the thickness of ice circa 1904. *Courtesy of the author.*

The Passenger Experience

blowing snow and crushing ice were all among the weapons the elements could employ to harass and, all too often, destroy steamships on the lakes.

> *The danger came soon enough in the shape of a fog, dense and continuous, as only a Lake Michigan fog can be. Day gave place to evening, but still the soft cloud filled the air, resting on the water, and making every thing as still and weird as dream-land. All night the whistle sounded at regular intervals a dreary, dirge-like note, that kept sleep from our eyes, and filled our minds with visions of possible ships sailing silently across our course in the mist, or unseen propellers bearing swiftly down upon us, with sharp prows pointed against our sides.*[64]

> *In 1843 we transshipped on to the good old steamer* **Missouri**, *commanded by Captain Blake, bound around the lakes, for Milwaukee and other upper lake ports. As we passed out of the straits and entered Lake Michigan a fearful storm burst upon us. Captain Blake said that it was the worst he ever saw on the lakes.*
>
> *My brother and I got out of our berth in the middle of the night and climbed in the almost total darkness to the deck. We wanted to see the storm in its might and glory. The main figure which we saw on deck was Captain Blake, who saluted us with the howl: "What the hell and damn are you doing here? Go below, damn you!"*
>
> *We retreated a little out of this sight. It was raining in torrents, with the wind blowing a gale. Captain Blake was standing by the capstan watching the sky and the waves, bareheaded, with his tarpaulin hat in his hand, and beating with it the capstan as if to punish it for the storm. Whipping the capstan by continuous blows with his hat until its oilcloth covering was in ribbons, he shouted in a voice of anger heard above the roar of the tempest the most tremendous oaths imaginable, damning the storm, the winds, the waves and him who "rides upon the whirlwind and directs the storm" as the cause of the hurricane through which we were plunging, with the water dashing over our bows and half-mast high above our heads.*[65]

> *We left Manitou Island, Lake Michigan, at 4 o'clock p. m. September 25, 1841, on the steamer* **Chesapeake**, *which contained three hundred passengers, a large quantity of freight and coal, eighty cords of wood, eighty mules, besides pigs, chickens, geese, ducks, etc.*

We continued our journey towards Chicago without any interruption, until half-past eleven p. m., when we were overtaken by a tremendous storm of wind and rain; it blew a hurricane, and the lake became as rough as it could be by the force of wind. I was awakened from a sound sleep by the cry, "We are all lost!"

I immediately leaped out of my berth and went to the upper deck. I saw we were in imminent danger of being wrecked; the bow of the boat was heavily laden, and frequently engulfed by the heavy waves that washed over her; at one time her bow ran under water and some thought she would never rise; the water set the mules and all the live stock afloat; washed away the partition; and the mules, pigs, chickens, ducks, and geese, were all hurled in one mass down into the steerage cabin, mixed pell mell with sixty Irish passengers, men, women, and children; at that moment the roaring of the wind, the rush of the waters, the peals of thunder, the flashes of lightning, the braying of asses, the squealing of pigs, the quacking of ducks, geese and chickens, the praying, screaming, and swearing of men, women and children, created a confusion of sounds which rent the air, and sent a gloomy thrill through the heart.

We immediately went to work, and helped all the passengers out of the water, and from among the beasts, upon the deck, so their lives were preserved, while all the fowls, pigs, and part of the mules were drowned or killed; many tons of water rushed through the boat, until the water stood nearly to the boilers; it drove the firemen from their places.

About this time, when the boat was laboring against the wind and tide one of the wheel chains broke, and the boat rolled over to one side. I again heard the cry that "all was lost," but about thirty of us caught hold of the two detached pieces of chain, and held them together until the engineer mended them with wire.

It took three strong men to manage the wheel; while the boat lay upon her side, it washed away a part of the state rooms; orders were given to clear the boat of everything that was movable; all the wood was fastened with stanchions; on the side that was down, the stanchions were knocked out by the passengers, and forty cords of wood tumbled into the sea at one surge; this caused the boat to right up. To add to the horror of the situation we were wrapped in darkness, as all the lanterns were dashed to pieces.

The men at the wheel labored hard for five hours to turn the boat round before they accomplished it, so that they could run before the storm. At

The Passenger Experience

Steamer *Lady Elgin* is seen in Chicago the day before being lost on Lake Michigan in this illustration by Samual Alschuler. *Courtesy of the Library of Congress.*

> *length daylight appeared, and with it a cessation of the storm in a measure. We returned to Manitou Island at four o'clock, being twenty-four hours out, mostly in the storm.*[66]

Unfortunately not all incidents ended with the steamer's safe return to harbor. Among the many passenger steamship disasters on Lake Michigan during the nineteenth century those with the most lamentable loss of life included the *Phoenix*, the *Niagara*, the *Lady Elgin*, the *Sea Bird*, the *Hippocampus* and the *Vernon*. At the time of each of these steamer accidents, the papers carried the stories of shocked survivors, all too often in the minority, as losses at sea were heavy in each tragic case.

BURNING OF THE PROPELLER *PHOENIX*, 1847

> *This terrible accident occurred about four o'clock on the morning of the 21st of November, 1847, on Lake Michigan, within seventeen miles of Sheboygan. The fire was first discovered under the deck, near the back*

end of the boiler; but it soon spread in every direction through the boat. There were more than two hundred passengers on board, and it soon became manifest that, with the means of escape which offered, not more than one-third of them could be saved. The excitement, consternation and despair which then prevailed among so many people doomed to a horrible death, cannot be depicted by any human language. Forty one of the passengers and crew (including the captain) betook themselves to the small boats, which would contain no more, and they were taken up by the steamer **Delaware**, which soon hove in sight, but not in time to save those who remained on board the **Phoenix**, more than one hundred and sixty persons, all but three of whom were drowned or burnt to death.[67]

BURNING OF THE STEAMER *NIAGARA*, 1856

The steamer **Niagara**, *of the Collingwood line, was burnt near Port Washington, on Lake Michigan, last evening. The* **Niagara** *left Collingwood at 2 P.M. on Monday with between 150 and 175 passengers. When two hours out from Sheboygan the passengers discovered fire issuing from the engine-room, and in a few minutes the whole cabin was in flames. The wildest consternation followed. The boats were lowered and all filled, but capsized, except one containing twenty passengers. Numbers jumped overboard and were instantly drowned.*

The steamer Traveller *was ten miles distant when the fire was discovered, but saved thirty persons. The propeller* **Illinois**, *bound down, also picked up about thirty and landed them at Sheboygan. A life-boat at Port Washington rescued twenty persons. Probably fifty or sixty lives are lost in all.*[68]

LOSS OF THE *LADY ELGIN* ON LAKE MICHIGAN, 1860

Late on the evening of Friday, the 7th September, the **Lady Elgin** *left Chicago with over four hundred persons on board, bound on an excursion up Lake Michigan. The wind blew hard from the north-east, and a heavy sea was running. But the party was a happy one. There were music and dancing in the saloon, and all went merry as a marriage-bell; when, shortly*

after two on the morning of the 8th, there came a sudden crash. Thirty miles from Chicago and ten miles from land, off Waukegan, the schooner Augusta, *making eleven knots an hour, came down on the doomed ship, struck her on the midships gangway, and then, having her sails set, and the wind blowing freshly, drifted off in the darkness. In half an hour the steamer sank in three hundred feet of water; and of the four hundred persons on board not a hundred were saved.*

A clerk of the ill-fated vessel states: "Instantly after the crash of collision the music and dancing ceased, and the steamer sank half an hour after. Passing through the cabins, I saw the ladies pale, motionless, and silent. There was no cry, no shriek on board—no sound of any kind but that of the escaping steam and surging waves."

One of the passengers gives the following additional particulars: "The hull went down, leaving the hurricane-deck floating. A great portion of the passengers were on the hurricane-deck. Most of them jumped off very soon, thinking that would sink. The hurricane-deck soon separated into five pieces. There were twenty-five on the part on which I was. The captain was on this. There were some military from Milwaukee, and six or seven ladies. The other four pieces went off with a number on each. We held cabin-doors for sails, and came down smoothly as far as Winetka. When within a few rods of the shore the raft capsized; the captain got one of the ladies back on it. A big sea came and washed us off again and the Captain was drowned."[59]

The bodies of less than half of the 430 confirmed lost were ever found. Because no official passenger list survived the exact number of victims is unknown. It was reported that in Milwaukee, where most of the passengers had originally embarked, the disaster orphaned over 1,000 children, and the entire city went into mourning over the tragedy.

Loss of the Propeller *Hippocampus*, 1868

Fifteen of the Passengers and Crew Saved—Twenty-six Lives Lost.

We left Benton Harbor at 10 o'clock in the evening. The sea, running from the southward, was quite heavy, there being a heavy swell on. The

wind increasing, the boat began to pitch badly, but no alarm was felt. In about an hour I went to the engineer's room, and finding water in the hold I then remarked to the wheelsman, Morrison, that we would be obliged to lighten our craft by throwing part of the cargo of peaches overboard from the promenade deck.

I spoke in tones so loud that the passengers heard it, and rushed out on the deck in great confusion.

In the meantime, the vessel was settling rapidly, and before any of the freight could be thrown overboard, water had commenced coming in through the after gangway and through the engine room into the hold. Within five minutes from that time she had gone on her side and was totally submerged.

There was intense terror among the passengers. I told them to help tear way the lifeboat; but not one stirred. They seemed paralyzed with fear. I was on the pilot-house trying to launch the boat, and ordered the wheelman to put the helm hard a port, and he did so, but to no purpose. I saw nothing could be done to save the vessel, and came down, and started forward. I got within two feet of the hatch, but was unable to reach it. I let myself into the water, and got hold of the mast, and floated along, hand over hand, until I

This illustration by W.B. Baird portrays the burning of the steamer *Sea Bird* on Lake Michigan in 1868. *Courtesy of the Library of Congress.*

The Passenger Experience

got to the masthead at the crosstrees. I was in fear of being entangled and sucked down with the sinking vessel, and so struck out about ten feet, and got hold of a desk, and kept afloat with that for a while. The vessel then sank, sinking with a suddenness which left no time for preparation.[70]

STEAMER *SEA BIRD* BURNED, 1868

About six o'clock on the morning of the 9th, the steamer Sea Bird *took fire off Waukegan, and the boat, with all its contents, except three passengers, perished in the flames or were drowned. The fire was probably caused by the porter's throwing overboard, ashes, with live coals which blew back among some wooden ware, packed in straw. There were about 30 passengers on board, and about 40 others connected with the boat. The only survivors as far as known are C. A. Chamberlain; J. H. Leonard and Edwin Hanneberry, passengers from Sheboygan. The latter makes the following statement.*

There was great confusion, and the fire spread so rapidly as to convince me that it had been burning a long time. Within five minutes the after part of the boat was in flames. I do not think that all the ladies had time to get out of their state rooms, and some of them and the children must have been burned. An effort was made by a portion of the crew to reach the small boats, but failed.

The survivors tell us that those who confided themselves to the tossing waves to escape the fiery demon that was destroying their only ark of safety on the wide waters, did not live above an average of four minutes in the almost icy cold of the furious sea.[71]

STEAMER *VERNON* SINKS IN LAKE MICHIGAN, 1887

The propeller Vernon *of the Northern Michigan Line, foundered during the terrible gale which raged on Lake Michigan yesterday, and it is almost certain that of her entire crew and list of passengers, numbering over 30, and probably close on to 50, not a soul escaped. No greater loss of life has occurred on any one wreck on the lakes this season.*

The first news of the disaster came to Chicago in a dispatch from Milwaukee, where the steamer **Superior** arrived last night. The **Superior** had passed not only large quantities of wreckage, but had passed, unable to succor, a raft and a small boat in which persons appealing in vain for help were seen. The **Vernon** was due at Milwaukee yesterday, and there was every reason to believe that the people and the wreckage were from that vessel.

"To pass one man on a raft appealing for our help, another dying from exposure, and a small boat in which we could see one woman and three men, one of the latter hailing with a coat stuck up on his oar, all being tossed about in a terrible sea without our being able to render them any assistance, was heartrending in the extreme," said Capt. Moran, of the **Superior**, in telling his story. "We were also fighting for your lives, our steamer having become disabled in the sea," said the Captain, "and it was three hours before we had made repairs so that we could handle ourselves, and then we were out of sight of the shipwrecked men. Their hearts must have been gladdened in their expectation of help from us. How inhuman they must have thought us when we passed them by, and within a mile, too, without even turning our vessel toward them! But with our steering gear disabled as it was we could not steer our vessel, and there was nothing for us to do but hope that some of the vessels coming up the lake astern of us might discover them and pick them up. I doubt, however, if any boat could have picked up the yawl in such an awful sea, and to have taken men off a raft would have been impossible. It was as heavy a sea as I have experienced in all my life on the lakes. Just to give an idea of it, the **Sandusky**, which we had in tow, sometimes buried herself so that only half of her masts could be seen. Once she staid under so long that I thought she was gone."[72]

Chapter 4

Working the Lakes

Sailors, I believe, are born and not made. I took to the boats when I was thirteen years old and have reached the age of fifty-two without being able to leave them, although I have tried several times.
—Fred Smith, Chicago

When discussing the history of passenger steamships on Lake Michigan it seems essential to also look at the role played by the many men who worked the lakes. Sailors, stokers, engineers, pursers, pilots, mates and masters (captains) all made careers on the grand, wild and often dangerous inland seas known as the Great Lakes. Sailing vessels had been plying the Great Lakes since the late 1600s and the first generations of steamships on Lake Michigan got their crews directly from the body of men who had learned the lake life on schooners. In fact, real *rope and canvas* sailors were required in those first steamers, some of which were converted sailing vessels, and all of which carried masts and sails for auxiliary power.

The size of the steamship determined the number of crew, as did the type of accommodations for passengers. A day boat for short excursions or a mosquito steamer designed for short coastal or island runs required less crew, especially in the way of domestic staff such as cooks, waiters and chambermaids. A night boat or an interlake steamer running from Buffalo to Chicago or Milwaukee would by necessity cater to cabin passengers and provide more amenities and staff. On many of the lake vessels, officers and crews operated with considerable informality. As early as the 1890s, women

Officers of a Great Lakes steamer pose in this photograph, taken sometime after 1913. *Courtesy of the author.*

worked on passenger steamships in the dining rooms and in preparing staterooms, but they were a minority, with most positions held by men. During both World War I and World War II, the number of women serving on steamships saw a temporary increase. Most officers on the lake steamers were Caucasian while African American deck hands, stewards and waiters were common.

> *The wages of men* [working aboard steamers on the Great Lakes] *in 1836 ranged as follows: The captain received from $600 to $1,000 for the entire season; the first mate from $36 to $40 per month; second mate, from $18 to $28 per month; steward, from $25 to $35 per month; engineer, from $50 to $90 per month; wheelsman, from $15 to $20 per month; fireman, $18 per month; sailors, $16 per month; first cook $25 per month; second cook $18 per month; third cook $10 per month; and other hands from $10 to $15 per month.*[73]

Working the Lakes

The following table shows crew positions and relative monthly pay scale at the height of passenger steamer service in 1890. Modern day wage equivalents are provided in parenthesis:

Position	Wage per month	Modern equivalent
Captains	$109.15	($2,650.00)
First engineers	$87.34	($2,120.00)
First mates	$71.56	($1,740.00)
Clerks	$66.25	($1,610.00)
Musicians	$65.00	($1,580.00)
Second engineers	$62.24	($1,510.00)
Stewards	$59.43	($1,450.00)
Second mates	$58.00	($1,410.00)
Cooks	$51.54	($1,250.00)
Firemen/Stokers	$36.51	($888.00)
Wheelmen	$36.01	($876.00)
Seamen/Sailors	$35.96	($875.00)
Lookouts	$33.77	($821.00)
Watchmen	$32.97	($802.00)
Porters	$25.22	($613.00)
Deck hands	$23.70	($576.00)
Chambermaids	$22.39	($554.00)
Assistant cooks	$20.98	($510.00)
Waiters	$20.44	($497.00)
Boys	$18.30	($445.00)

While ship's boys and waiters were at the bottom of the economic ladder, seamen or sailors were less than half way up. Their services, while essential, were less valued than the stewards, mates, cooks and even musicians. This was because sailors tended to be undereducated, somewhat transient in their employment aboard any given ship and often in plentiful supply. "Seamen's

wages vary considerably from year to year," recorded J.B. Mansfield in 1899, "for they are subject to the same influences that regulate other wages."

The titles seamen and sailors, which were in common usage on the lakes, are not completely accurate, given that the term *inland seas* is used for its descriptive nature rather than geographical accuracy, and that the steamships generally steamed rather than sailed. At times, the title seamen was used to cover nearly all nonlicensed crew positions, including wheelmen, lookouts, watchmen, deck hands and firemen. In part this can be explained by the cross-disciplinary nature of the jobs aboard a Great Lakes steamship. The Lake Seamen's Union of the late nineteenth century was "made up of wheelsmen, watchmen, lookoutsmen, bargemen, deck hands, coal passers, etc." Although there was specialization, the unique nature of travel via the lakes, rivers, straits and lock systems that made up the Great Lakes routes required that officers and crew be "jacks of all maritime trades."

> *To all this progress the American sailor of the inland marine has contributed an important share. If his voyages are shorter than those of the ocean 'tar' his work is more laborious, for he must be both sailor and stevedore due to the constant loading and unloading at every port.*[74]

Responsibilities of the captain, also known as the master of the vessel, included the overall safety and operation of the steamship, the conduct of crew and the safety of passengers. The mates were in charge of the running of the ship, including fueling, taking on, stowing and discharging cargo, supervising the seamen and assisting the captain.

> *It shall be the duty of the mate of every inland or river steamer carrying passengers to assign to deck or steerage passengers the space they may occupy on board during the voyage, and to supervise the stowage of freight or cargo, and see that the space set apart for passengers is not encroached upon. He shall also carefully examine all packages of freight delivered on board for shipment, with a view to detect and prevent any combustible or other dangerous articles prohibited by law being delivered on board.*[75]

> *Many of the minor cares about a steamer are shouldered by the first and second mates. The first mate is usually an elderly man. He attends to the*

Working the Lakes

Steamer *Peerless* goes through the locks at Sault Ste. Marie, Michigan, with crew, passengers and the ship's band lining the rails. *Courtesy of Bayliss Public Library, Sault Ste. Marie, Michigan.*

hiring of deck-hands—a task which recurs at nearly every port and always at the end of a round trip; to the cleaning, painting and burnishing of the ship; keeping things in place and having an eye on the stores and supplies, besides being on six hours watches twice out of every twenty-four. He is the mouthpiece of the captain; transmits all his orders 'aft' and looks after things generally.

The second mate is usually young and ambitious (perhaps only lately promoted from the wheelhouse, and with his gaze steadily fixed upon the beacon light of a captaincy), he does everything the captain and mate impose upon him. He watches the other double six hours of the twenty-four; does the fine work about the boat; attends to everything aft when entering and leaving port; never sleeps and always looks pleasant—except to the deck hands.[76]

At length the steamer reached her dock, and was made fast by the wild men, who ran around the capstan at furious speed, while the mate, having cast ashore the coil of small rope, occupied himself in hanging head downward over the side and bellowing orders to the unseen slaves below.[77]

Stevedores load copper on steamer *Juniata* in Houghton, Michigan, in 1905. *Courtesy of the Library of Congress and Detroit Publishing Co.*

The purser's area of responsibility was the business of the steamer, including cargo manifests and passenger ticketing, while the freight clerk held dominion over the cargo and mail.

> *The clerk of the steamer, or purser, is the man of business, and the prime minister of the gay vessel.*
>
> *In his limited den forward, he is assailed by steward, waiters, cook, deck boys, cook's boy, captain, pilots, engineers, and passengers, who are continually asking questions. As he is responsible for the good name of the boat, he is expected to be invariably gracious and polite.*[78]

The chief steward was responsible for passenger services including the dining room, staterooms, saloons and lavatories and supervised the cooks and stewards. Cooks prepared all the meals for passengers and crew

Working the Lakes

A member of the steward's staff is seen on the grand stair of a steamer in 1896. *Courtesy of the Library of Congress.*

members. The stewards, also called waiters, served the meals in the dining saloon and cleaned the lounges and staterooms for the passengers. Some steamers employed chambermaids for these cleaning duties as well.

> *Mr. Bloomer, our indefatigable steward who acts as clerk, steward, "chief cook," and "headwaiter" (for he makes himself generally useful), had taken care to provide a dainty repast, having with him, also, the cook, waiters, etc. The band being in attendance, dancing soon commenced. Other exercises and sports were kept up with spirit, until dinner was announced. After dinner one gentleman attributed his fall to the circumstance that Mr. Bloomer, in compounding his 'lemonade,' had substituted champagne for*

water! For the offence, the steward was immediately arraigned, but Mr. Corwin, who undertook the defense, obtained a verdict of acquittal, not so much upon the merits of the case as by showing that the services of the steward were indispensable to the continued enjoyment of all parties.[79]

The chief engineer, assisted by the second or assistant engineer, was responsible for the steamer's machinery and operation. The firemen, also called stokers, were supervised by the chief engineer and responsible for feeding the wood or coal fuel into the furnace to keep the steam up in the boiler.

The engineer, with his assistant, his oilers and his firemen form a department by themselves; they control the heart of the monster. The chief, though obedient in taking orders from the captain about maneuvering the ship, obeys instructions from headquarters only as to speed, consumption of coal and such matters, and is a good deal like a civil service government employee, under the captain but in a sense independent of him.[80]

The marine engineer is the one class of marine craftsmen that, above all others, has been obliged to keep pace with the developments of this fast speeding age. His importance is not always recognized by the non-seafaring man, as his identity is concealed from the view of those who travel in steamers. Down in the bowels of the vessel he controls not only the propulsion, but the steering, lighting, pumping, anchoring and ventilation of the modern marine structure. The eyes that steer the ship are those of the officer of the watch, but the brain that forces the steamer to her destination and regulates her internal economy is that of the marine engineer.

The class of men chosen to take charge of the steamboat possess more than ordinary intelligence, courage and resource, and in case of disaster to steamboats, involving loss of life, the engineer is among the doomed. He stands to his post as long as duty and humanity require.[81]

Down in the steaming, dusty, gloomy stokehole, stripped to the waist, gasping for breath and sweating rivers, the stoker throws the coal into the fiery maw of the furnace. The stokehole is situated far below the water line at a point almost amidships. A long, grimy room it is, hemmed in by steel walls and coal bunkers, with fiery furnace doors that send out gleaming rays of light into

Working the Lakes

Stokers are seen in the steamship's fire room. *Courtesy of the author.*

the apartment, the only light that the room ever receives. It has no windows and few doors. In the ceiling above great ventilators pierce the steel. Currents of cool air take the place of that sucked in by the furnaces. The room is filled with a sickening heat that only the experienced stoker can stand.

In this room the stoker works, and works hard. The duties are so severe that he is rarely required to work a shift of more than four hours. That is, he works for four hours, then has eight hours' rest, and then works four hours. A line of coal passers constantly moves, each man trundling a barrow, into the stokehole. As the coal is dumped on the floor the stoker, armed with a long shovel, jerks the chain that opens the door, seizes a shovelful of fuel and dashes it into the great bed of glowing, roaring flame, where it is licked up almost before the stoker, with half shielded face, can close the door.

Each stoker has an allotted number of furnace doors to take care of, according to the size of the ship and the capacity of its boilers. He has scarce a moment's rest during his shift, and when he is not throwing coal into the glowing ovens of the flame he wields a rake in the burning fuel, and with the nicety of experience keeps the great furnace at an even heat. The steam gauge over his head is watched and every fluctuation noted. The assistant engineer, who superintends the work of the stoker, is constantly on the alert. The life of a ship may depend on the proper handling by the engineer.

In spite of their hard duties the stokers are healthy, strong and vigorous men. The intense heat in which they work tans their skin a dark brown.

This photograph shows triple wheels in a large steamer's wheelhouse in the 1890s. *Courtesy of the Library of Congress.*

They are fairly well paid and have many liberties. They are idle more or less when the vessel is in port and little steam is kept up.[82]

The pilot's chief responsibilities included the safe conducting of the steamer in and out of ports, through narrow channels, up rivers or along coasts where the navigation was especially difficult or dangerous. The pilot superseded the wheelmen, giving directions for the careful and precise steering of the vessel.

During the peak years of steamship travel on the Great Lakes, steamer pilots were expected to know all the many buoys, lights and signals that marked the manifest waters, shoals and hazards of the lakes. During this period, a passenger steamer en route between Buffalo and Milwaukee would encounter more ships in a single trip through the narrow channels of the St. Clair and Detroit Rivers than a deep-sea ship would see between New York and the East Indies. Most of the ships met would be mammoth steel freighters and passenger vessels of considerable size.

Working the Lakes

The wheelhouse and wheelman of a small steamer are seen in this picture from the 1870s. Courtesy of the Library of Congress.

The pilot was charged with avoiding collisions not only with other boats, but with floating wrecks, rafts, sunken rocks and shoals. He needed to know by sight the landmarks of a hundred points in order to avoid disaster "on account of misplaced buoys or unlighted ranges."[83]

On the Great Lakes, it was required that "every master and mate of a steamer must also be a licensed pilot and be able to pilot his ship through all the difficult channels and along the five thousand miles of dangerous coasts, and besides being able to take the ship safely into one port, as the ocean pilots do, he is expected to be able to take his ship into the scores of harbors that abound on the Great Lakes."[84]

According to J.B. Mansfield's *History of the Great Lakes*, 1899:

The wheelmen are to the Lakes what the quartermasters are on salt water. Theirs is a tedious though not physically hard task, particularly on ships having steam steering gear which requires really but an infant's touch to turn the wheel. The wheelman is learning to be a pilot, receives orders to steer a certain course and must follow that to a dot—a most wearying job to stand there for six long hours looking for land marks and alternately watching that needle point that will wobble, and better had he never been born if, through drowsiness or other weakness of nature, he steers a quarter point off, or if in a channel he be too slow to obey instantly the order from above

to "Port-a-little,"— "E-a-s-y," "Nothing to starboard" or "S-t-e-a-d-y." He keeps the "log," noting every point passed, time, and direction of wind and steering course and rings the bells for the other watch to go on duty.[85]

There is not an instance in America of the man at the wheel standing, as with us [English], close to the rudder at the stern of the boat. The helmsman is always perched up aloft on the highest deck, where we place our foremast, giving him a complete command of all before him. There he sits in an elegant office, enclosed on all sides with windows, turning his wheel according to the direction he wants to steer in; which wheel communicates, by means of two rods of iron, about three-eights generally, with the tiller; and as none of the passengers ever see him, nobody ever thinks of him, and much less talks to him.[86]

Going out on the forward deck, we seated ourselves at the bows. Here a ladder led up to the wheel-house, where a keen-eyed man gazed so fixedly over the water that every time we noticed him we fancied he must see something there, and unconsciously found ourselves looking for a water-spout, or at least a mermaid, in the gray expanse ahead.[87]

The seamen—sailors, deckhands, lookouts and watchmen—were employed variously keeping watch, painting and cleaning the vessel, polishing brass, loading and unloading cargo and livestock and "taking on" wood (later coal) to fire the steamship's boilers.

The lookout's post is forward at night and in fogs where he peers ahead and informs the officers on watch that there is a white light ahead, or a red light on the port bow, or gives other seemingly useless information. At other times he scrubs, paints, washes, makes rope fenders and haughtily shows the lowly deck hands how to polish brass. The watchmen do mostly the same thing except that instead of looking out for lights ahead they tend lights and prowl around looking for possible fires within.

The deck hands pass the [fuel] from the bunkers to the fire room, shift freight, wash and polish everlastingly at the brass work, scrape spars and decks, remove from the latter the blisters of some 20 odd coats of paint, and apply a fresh coat.[88]

Working the Lakes

A pilothouse and superstructure of the steamer *Greater Buffalo*, with her officers inset, are seen in this 1928 picture. *Courtesy of the author.*

The nature and temperament of the Great Lakes sailor has often been commented upon as unique to the profession in many regards. Variously referred to as Jack or Jack Tar, the sailor is both praised and slighted in descriptions written throughout the period of passenger steamship travel on Lake Michigan.

> *Our thorough-going sailor, rude and unlettered though he may be, never allows himself to be esteemed an ignoramus. The confinements and restraints of shipboard may make him careless as to the proprieties when ashore, but his manifold experiences and his habit of thoughtfulness induced by long watches result, naturally, in no small amount of native commonsense, a certain feeling of superiority over the "poor fellas ashore," and a readiness to find a reason for all things.*[89]

> *Down to the poorest paid stevedore, the sailor of the lakes is usually a happy individual, contented with his life and its pleasant associations.*[90]

> *Captains generally will stoutly maintain that a sailor's life is a dog's life, and that they would never allow a son of theirs to go on the water. Still,*

> *some of them wax fat and jolly....Jack has some fun aft of the engine house after supper. You hear some good jokes and considerable horse-laugh and play; and I suspect that there is often a quiet game in the kitchen galley where dimes and quarters change owners.*[91]
>
> *Dim forecastle and plunging yard, breezy pilot house and throbbing engine room have their heroes and their inspirations quite as worthy imitation as the more exalted quarterdeck and bridge.*[92]

While the ranks of ship's captains, mates and pilots were, for a hundred years and more, filled by men who had by necessity started as seamen and worked their way up in their profession, there were many more examples of seamen who demonstrated an itinerant nature by moving from ship to ship. This predilection often slowed, if not extinguished, opportunities for advancement. "The ship's crew generally stick to her for a season anyway," explained J.B. Mansfield in 1899. "Though some stick and climb even to the bridge, most of them go on when particularly desirous of reaching some other port."

The seasonal nature of the work for lake mariners may also have been a contributor to the impression and actuality of seamen as less than steady. While advances in steel hulls and ice-breaking technology in the last half of the nineteenth century allowed the use of some steamers on Lake Michigan throughout the winter, most steamships and their crews took the late winter off due to high insurance rates and the closing of the straits.

> *A few steamers have been kept running all winter between Chicago and points along the Wisconsin shore. A big business has been done by [railroad] car ferries across the lake from Milwaukee; but all this does not count with the mariners who are now getting ready for work. The only navigation they recognize is that which begins with the opening of the straits.*[93]

In 1897, a writer for a Chicago newspaper described in detail the importance of the opening of navigation to the sailors whose livelihoods depended on the lakes:

> *Ho for the Straits!—The opening of navigation is a great event for the thousands of sailors who have been wintering at the various lake ports.*

Working the Lakes

Steamer *H.W. Williams* ran the South Haven–Chicago route. Renamed *Pere Marquette No. 8*, it was destroyed by fire at Manistee on Lake Michigan on October 26, 1927. *Courtesy of the author.*

There is a little stretch of ice around the Straits of Mackinaw, a little more in Lake St. Clair, and some large floes in Lake Erie. This is now all that keeps the 600 vessels, which comprise the lake fleet, still snug in their winter quarters. The coming week crews will begin to gather. The machinery of the big steamers, taken apart last fall and scattered around the engine rooms so that water would not freeze in the pipes, will come together again. Sails will be pulled down from a hundred lofts. From numberless sailors' lodging houses will come forth the men who will sail the ships.

Every pleasant day the vanguard is already at work painting the sides or patching up the decks. Many craft, deep-laden with grain, are being moved down the river to be nearer the harbor entrance when the news comes the 'straits are open'.

California seems to have been attractive to many lake faring men the last winter. A score or more have been to Cripple Creek and succeeded in putting away the savings of last season into holes in the ground. Gold mines absorb more of the earnings of lake navigators than any other class of men who depend on wages for support. Some the last winter have been up in British

Columbia, and have invested there. Now they are coming back. Ship keepers are being paid off and let go until another winter comes around.

It will be a great day for the keepers of the sailors' lodging-houses when navigation opens. The money of the average sailor disappeared long ago. He has had the same thing happen every winter since he can remember, and the fact that his money is gone, which is so troublesome to many people, does not worry him in the least. The keeper of the lodging-house is not troubled by this little circumstance either, for he knows as soon as the 'boys' get to work this spring the winter bills will be paid.

The captains of Lake Michigan passenger steamships came in nearly every form imaginable during the 130 or so years that the role was attended by more than a handful of men. To become a master of a lake steamer was no easy matter. The membership was made up of men who, by uniting energy and close application to their duties, worked their way up through the ranks of their profession to win the confidence of ship owners, crews and peers.

In later years these men also stood a rigorous examination by an appointed government expert, whose duty it was "to investigate character and habits and the ability [of the candidate] to keep cool and clear headed in moments of great danger." The examinations included a detailed test on the geography of the whole lake system, with would-be masters expected "to recognize at once, even though only glimpses can be caught through the fogs or snow, the headlands of any portion of the continuous shores, wherever

An officer's dining room is seen on the steamer *Dean Richmond*, which was built in Cleveland in 1864. The ship was lost with a crew of eighteen in a storm on Lake Erie on October 14, 1893. *Courtesy of the Rutherford B. Hayes Presidential Center.*

they may be," and to accurately state the direction and exact location of any of the thousands of submerged rocks or shoals within the scope of Great Lakes navigation.

Once a licensed master and ship's captain, these hardy souls had the satisfaction of being at the peak of their profession but with little opportunity to relax, as theirs was a particularly taxing and constant labor, with disaster never far at bay.

> *In few, if any callings are there so many vicissitudes. This vocation requires almost absolute accuracy. Among lake masters are men who, after a decade of untiring labor, have met with slight accidents, and lost all they have gained by many years of hard labor, but, like the courageous men they must be to follow their vocation, they start out again at the bottom and work up.*[94]

> *The lake master is making one port and sometimes two ports a day. He has long stretches of rivers with narrow channels, and perhaps a hundred vessels to meet and pass, during which time he is on the bridge in fair weather and foul. He takes his vessel into and out of every port. He has to see to and prepare his manifests, his clearings and other custom-house rigamarole; look after his freight bills and attend to the constant loading and unloading at every port, and he must see that this is done scientifically, so as to keep an even keel.*[95]

> *There is no class of skilled labor in any profession who give a more exhaustive service, or who has as grave responsibilities resting upon them as the masters and pilots. Few people who travel in steamers realize the grave responsibility of the solitary man in command. A slight error in judgment on his part would send many into eternity without a moment's warning.*[96]

> *The lake master must poke around in perhaps a dozen different docks, pass 20 drawbridges and dispute the right of way with as many if not twice that number of vessels. His harbor cares are so numerous and weighty that I have known of devoted husbands, whose ships have been at their home port for days at a time twice a month, but who could not get home more than once in an entire season!*[97]

Lost Passenger Steamships of Lake Michigan

A passenger steamer takes on coal in the busy Chicago River, east of Rush Street Bridge, in 1905. *Courtesy of the Library of Congress and Detroit Publishing Co.*

In dense fogs and stormy weather this "guiding genius of the deep" frequently puts in twenty-four to thirty hours steady watch. The latter end of the season, October and November, when for weeks continuously "the mad winds blow and the billows roar," is the time when one can best judge of the responsibilities, cares and physical strain on a lake mariner.

Imagine yourself standing in a little coop, perhaps eight feet square, with no shelter other than a canvas fence chin-high, with a bleak, howling wind, and the snow, sleet and spray encasing you in a rigid frozen mold; there to be tossed up, down and sideways. You are unable to see a distance of over a hundred feet. You must keep head to the wind. You know your whereabouts by the blindest reckoning only. You have your vessel, many thousand dollars' worth of cargo, and perhaps passengers to think of. You realize that another vessel may crash into you at almost any moment or that something about your steering apparatus or running gear may give out at the wrong time, and I'll wager that you would go down upon your knees and implore Heaven to bear you safely back to your cozy library.[98]

Chapter 5

Early Twentieth-Century Steamers

To many thousands of tired mothers and street-weary children the chief glory of Lake Michigan will always remain its 'across the lake' excursions, when, loaded down with lunch baskets, sacks of fruit and crockery of every onceivable kind, whole families march off to the docks and start out for the unknown land of Michigan.
—John R. Rathom, 1910

By the last decades prior to the dawn of the twentieth century, railroads had expanded to such an extent that they presented aggressive competition to the Great Lakes steamship lines in carrying both passenger and freight traffic. In response, advertising for the vessels shifted toward promoting the advantages of pleasant, economical and relaxing steamer excursions and vacations on the lakes. This was an area where the railroads were at a disadvantage. Not only was steamship travel less expensive, at least by the mile, but it was also more comfortable, so long as the ships and passengers did not meet with storms on the lake. Steamship lines were quick to point out in florid detail the many benefits of steamship travel in brochures and advertisements.

You leave all cares behind when, with fluttering of colored serpentine, cheery shouts of farewell and the stirring music of the ship's band, the steamer pulls away from the pier and sets a course that carries you over twenty-one hundred miles and through seven of the most delightful days that can be

Children on excursion are seen aboard the steamer *City of Benton Harbor* in Chicago in 1905. *Courtesy of the Library of Congress.*

imagined. A spirit of unrestrained friendliness pervades the ship. Happiness and gaiety are in the air. New friendships are quickly formed. Boredom and loneliness are impossible here.[99]

The management desires to call special attention to the opportunity a regular round trip affords a busy man to get a brief rest and a splendid short vacation. Just think! From any port on the route all the way around and back home, a two day and two night trip on the bay and lake, meals and berth included, for the sum of $4.00.…This is the best trip in the United States for the Money, and the rate will prevail all summer. We want travel and offer this rate with the good service as an inducement to try a trip on the Lakes. The Scenery enroute is grand—great limestone bluffs, cool, green forests, many islands and passing steamers, clear, cold water, refreshing air, cool breezes, in fact a delightful, quiet trip with plenty to eat and a nice clean stateroom at one's disposal. The scene from a steamer deck is immense by day.[100]

Early Twentieth-Century Steamers

Steamer *Eastland* ran on Lake Michigan for the St. Joseph-Chicago Steamship Company between 1912 and 1915. *Courtesy of the University of Detroit Mercy Library.*

A group of summer lake tourists pose with the steamer *Chicora* in the background prior to 1895. *Courtesy of the Historical Collections of the Great Lakes, Bowling Green State University.*

Each of these steamers is equipped with everything to make a voyage of summer comfort and service. The expeditious schedule upon which these steamers travel is made for maximum convenience in arranging connections and trips....To the summer tourist, the business man, the banker and the commercial traveler the steamers offer the very finest day voyage. For a popular trip at a popular price, the up-to-the-minute cruise of the Great Lakes caters to the wants of all who dislike the thought of a long dusty journey by rail.[101]

You will enjoy complete relaxation on this trip. Further, you will associate with congenial, refined passengers and will be aware of a personal note of attentive service that will bring added pleasure to your trip.[102]

This voyage adds to your summer vacation, for the steamers are just as beautiful as useful, skirting one of the most picturesque shore lines in North America. The vacationist can find no more charming means of extracting the last ounce of health and fun from his or her "rest up" than by a Great Lakes cruise.[103]

Night excursions by steamer provided another entertainment opportunity from many of the Lake Michigan ports including Chicago, Milwaukee and Green Bay. These were billed either as romantic, starlit cruises or rollicking dance parties afloat—or sometimes both!

A moonlight trip on the steamer is a pleasure that will linger long in the memory. You sit on the upper deck watching the sparks from the steamer's huge stack chase each other to the broad surface of the bay, which gleams like a lake of silver. Under these conditions you feel at peace with yourself and mankind and sit contented to drink in the glories of the scene.[104]

As you move out into the clean, bracing air of the lake, the hustling city behind you becomes an enchanting picture of light, with multi-colored towers glimmering far to the north and south, linked together like a shining necklace by miles and miles of light on the Outer Drive system. But it's the brilliance of the downtown skyscrapers that will live longest in your memory—giant pillars of light etched against the darkened sky.

Early Twentieth-Century Steamers

You may think you know the ideal spot for dancing—but wait until you spend an evening on board the S.S. Roosevelt. *In our Marine Ballroom, largest on the lake, the charm of delightful music and the rhythmic swish of the water blends in irresistible harmony. No charge for dancing. And between dances you can always be sure of a cooling lake breeze out on deck, or refreshments the way you like them in the Casino or Davy Jones' Locker.*[105]

A Moonlight Cruise on the popular Steel Steamship City of Grand Rapids *is a wonderful tonic after a hot, busy day. The restfulness of this short trip, combined with the unusual view of Chicago's Skyline by night, is always enjoyable. Dancing to the music of a popular orchestra is free. Many people, after an evening at the theatre, find this popular trip a perfect way to end a busy day.*[106]

Passengers are seen on the upper deck of a lake steamer, circa 1907. *Courtesy of the author.*

One of the most significant and often-promoted advantages to steamship travel in the early years of the twentieth century was the relatively low cost of travel on the Great Lakes when compared with ocean cruises and East Coast resort destinations.

> *The Lakes are primarily the "poor man's pleasure grounds" as well as his roads of travel, on them he may ride in company with millionaires and dine with the scions of luxury and fashion without overreaching himself financially. This has been called the democracy of the Lakes. It is a condition which exists nowhere else in the world on such a large scale. It means that what President* [Theodore] *Roosevelt describes as "the ideal American life" has been achieved on the Lakes; that the bank clerk is on a level, both socially and financially, for the time, with the bank president, with the same opportunities for pleasure and with the same luxuries of public travel within his reach. The 'multi-millionaire', who boards one of the magnificent passenger steamers at Buffalo, Cleveland, Detroit, or Chicago, or any other Lake port, has no promenade decks set apart for himself and others of his class, as on ocean vessels.*[107]

Despite the undoubted truth of the argument that cruising the Great Lakes was both highly rewarding and much less expensive than an ocean cruise, it seems that the traveling public outside the lake states region wasn't convinced. In 1908, 16 million passengers traveled on Great Lakes vessels; however it was estimated that less than 500,000 were foreign tourists or pleasure seekers from large eastern cities.[108]

> *To-day it is almost unknown outside of Lake cities that one may travel on the Inland Seas at less cost per mile than on any other waterway in the civilized world, and that the pleasure-seeker in New York, for instance, can travel a thousand miles westward, spend a month along the Lakes, and return to his home no more out of pocket than if he had indulged in a ten-day or two-week holiday at some seacoast resort within a hundred miles of his business.*[109]

During the years between the economic crash of 1857—which ended the era of the palace steamers—and the 1890s, passenger traffic on Lake

Early Twentieth-Century Steamers

Michigan had been accommodated by steamers ranging in size from 150 to 300 feet in length; however, "the impetus given about 1893 to tourist travel on the water highways of the lakes resulted in the construction of many splendid new steamers of larger size and capacity." These ships made up the premier lake ships of the early twentieth century.[110] Among the notable passenger steamships on Lake Michigan during this period were the *North Land, Theodore Roosevelt, Virginia, Christopher Columbus, Manitou, City of Benton Harbor, City of Chicago, South Haven* and *Indiana*. In 1910, James Cooke Mills provided descriptions of these and other Lake Michigan passenger steamers complete with notes on destinations, amenities and routes.

Steamer *North Land* is seen docked beside wharf at Mackinac Island in 1910. *Courtesy of the Library of Congress.*

> *The steamer* **North Land***, on the southern route to Chicago, bears off to the west from Mackinac Island, and, after a turn to the south continues down the long expanse of Lake Michigan for part of an afternoon and a night, and, in the early morning of the third day from Buffalo, arrives at Milwaukee, the "Cream City," situated on a high bluff towering above and overlooking a beautiful bay.*
>
> *From Milwaukee to Chicago is a short run down the west shore of the lake, past the flourishing towns of Racine, Kenosha, and Waukegan.*[111]

When blocked from building or buying a railroad to Chicago, James J. Hill, the Minnesota railroad magnate known as the Empire Builder, invested in a fleet of cargo and passenger steamships on the Great Lakes. Hill's two passenger ships, the *North West* and *North Land*, entered service in 1894 and 1895. The ships were designed exclusively for passenger service and called at the ports of Duluth, Chicago, Detroit, Cleveland and Buffalo. Identical in design and furnishings, the sister ships, built at a cost of $1,600,000 each, had a passenger capacity of 450 and carried a crew of 185.

> *The steamships* **North West** *and* **North Land***, of the Northern Steamship Company, present a most interesting study. In point of size they may be placed in a class almost by themselves, and moreover, being exclusively passenger ships, carrying neither freight nor express matter, they are to the lakes what the limited trains are to the trunk lines of railway. They closely resemble a large type of Atlantic liners, and, indeed, it is hard to believe, upon seeing either in mid-lake or the connecting waterways, that some giant of the briny seas has not been transplanted into the fresh waters.*[112]

Proud of the exclusive service on their ships, the line claimed "it equals or surpasses that of the best clubs and hotels in this or any other country. Telephones connect each parlor room with office. Each steamer has a first-class stewardess, who is there to look after the comfort of the lady passengers. The cuisine and table appointments are of the best possible, and under the management and direct supervision of a competent steward. The waiters are white men, speaking English, French and German, and are secured from the best cafes in New York."[113]

Early Twentieth-Century Steamers

The Northern Michigan Transportation Company operates three steamers on the northern route, of which the Illinois *and* Missouri, *built in 1899 and 1904 respectively, are sister ships. They are of steel throughout, registering two thousand, four hundred and fifty tons, and are two hundred and forty feet in length by forty feet beam. The steamer* Kansas *is a wooden steamer, two hundred feet in length by thirty-three feet beam, and was built in 1870.*

The splendid steamer Manitou, *of the Manitou Steamship Company, built and put in service between Chicago and Mackinac Island and Northern Michigan resorts during the Columbian Exposition in 1893, has continued on this route each season since, making semi-weekly trips. In point of size, construction, and interior appointments the* Manitou *compares favorably with any vessel of the steamship class, which, planned to accommodate tourists for long voyages as well as for day trips, plies between ports at opposite ends of the chain of lakes. There are broad decks, ample cabins, and luxurious staterooms and every convenience for four hundred passengers.*[114]

The famous whaleback passenger steamship, *Christopher Columbus* was also built for the 1893 World's Columbian Exposition, sometimes called the Chicago World's Fair. The grand event was held in Chicago to mark the 400th anniversary of Christopher Columbus's first voyage to the Americas. Like the *Manitou*, the SS *Christopher Columbus* was commissioned to provide service to the hundreds of thousands of visitors to the exposition. Additionally, it was hoped by her owners that she would convincingly demonstrate the advantages of the ship's unique whaleback design. The only passenger ship of her type, the *Christopher Columbus*'s cylinder-like body, more than 360 feet in length, "tapered from the middle toward the bow and stern; with the ends of the cylinder lifting high out of the water like a birch-bark canoe." The vessel was "lighted throughout with electricity" and elegantly furnished, the grand saloon containing several fountains, a sky-lighted promenade deck and large aquarium filled with lake fish. The cabins and public spaces were fitted out with oak paneling, velvet carpets, etched glass windows, leather furniture and marble. Shops and restaurants were provided for the passengers. "Above the main deck are built the promenade, upper, and hurricane decks. Being a day boat the decks are wide and open except for observation and dining saloons, and the passenger capacity is thus greatly

Lost Passenger Steamships of Lake Michigan

An impressive load of passengers is seen aboard an excursion steamer in the early twentieth century. *Courtesy of the Library of Congress and Detroit Publishing Co.*

The innovative whaleback steamer, *Christopher Columbus*, is seen on Lake Michigan. *Courtesy of the author.*

increased, and exceeds four thousand. The engines are of five thousand horse-power, sufficient to drive the stanch vessel at a speed of eighteen miles an hour, in all conditions of weather and sea."[115] Besides conveying patrons from the city to the exposition, the *Christopher Columbus* made excursions to Milwaukee and neighboring ports, "upon which occasions it proved itself the fastest boat on the lakes."[116]

> *On a beautiful morning about the end of June I left Fernwood for the Goodrich steamship landing, near the mouth of the Chicago River, which flows into Lake Michigan. We were soon on board the* S.S. Christopher Columbus, *which was sailing for Milwaukee—a distance of 85 miles from Chicago. These big Lake Michigan boats have three or four decks for the accommodation of passengers, of whom they can carry an enormous number.*
>
> *The* Columbus *was comfortably furnished, and the passengers were entertained all the way with classic music by an efficient orchestra. There was a restaurant at the forward end of the cabin, and below the main deck a lunch room. Other accessories of the steamer were the main bar, palm room, soda fountain, news stand, fruit stand, barber's shop, bootblack stand, clubroom, and drawing rooms. There was also a wireless telegraph office. The passage of the boat from the river into the Lake was an interesting experience, and the trip northward was delightfully exhilarating. The boat kept in sight of the land all the way, and prominent features of the coast were easily descried. Passengers could parade the decks of the ship and enjoy the pure fresh air, or they could enter the music saloon and listen to the fine playing of the orchestra. Various itinerant craftsmen were to be found on board the* Columbus *engaged in the production of souvenirs. One of these was an Indian, who was surrounded by spectators during the greater part of the voyage while he deftly constructed mother-o'-pearl brooches, with an ornamental lettering of the names of the purchasers or their friends. He sold these as fast as he could make them. The boat took five hours to do the trip, but there are many forms of enjoyment on board these steamers, and the passengers never wearied.*
>
> *Towards evening, after our pleasant hours in Milwaukee, we again boarded the* Columbus *and were soon ploughing the expansive and untroubled waters of Lake Michigan on our return to Chicago under the*

sunshine of a perfect American day. I need not recapitulate the sense of comfort and pleasure experienced on the boat, but I cannot close without mentioning the wonderful sunset that was witnessed upon the Lake during the approaching twilight and the rising of that glorious orb, the moon, which 'hung her lamp on high.' Nearing Chicago, the great array of city lamps gradually came into view, illuminating in one unbroken line mile upon mile of the Lake Shore, while in the background the eye was riveted by a brilliant blaze of lights from the great emporiums in the heart of the city, of many beautiful colours and remarkable designs, whose ever-changing hues, produced by mechanical art, presented a scene that fascinated the thousands of spectators who lined the decks of the ship. Add to this the illumination of all the larger craft on the water, from deck to masthead, and a faint idea may be conceived of the grandeur of a moonlit night on Lake Michigan in the vicinity of Chicago.[117]

By 1910, the *Christopher Columbus* had already served fifteen years on the Chicago and Milwaukee route. Having been acquired by the Goodrich Transit Company, it was the largest of nine passenger steamers serving the line.[118]

This photograph shows the rear view of the steamer *Christopher Columbus*. *Courtesy of the author.*

Early Twentieth-Century Steamers

Next by size in the Goodrich fleet, "but equal in speed and seaworthiness is the steamship *Virginia*. She is fitted up as a night boat, providing every comfort for travellers." Running with the *Virginia* on the night route between Chicago, Grand Haven and Muskegon, was the steamer *Indiana*. On the night route between Chicago and Milwaukee were the steamers *Iowa* and *City of Racine*, "practically of uniform size and speed with the *Indiana*."[119]

> *The oldest steamers now in service* [for the Goodrich line in 1910] *are the* Sheboygan, *built in 1869, and the* Chicago, *in 1874. These with the* Georgia, *which came out in 1880, and the* Carolina, *ply between* [Chicago] *and Milwaukee to the ports along the Wisconsin shore, including Manitowoc, Sturgeon Bay, Menominee, Marinette, Washington Island, and Escanaba. On this route they make four to six trips weekly in sight of land, with one trip extended to Mackinac Island.*[120]

The Graham and Morton fleet, in 1910, was composed of four large steamers of steel construction. "The Graham and Morton Line is a powerful factor in the passenger and fruit business between Chicago and St. Joseph,

Mothers and children are seen on the deck of steamer *City of Benton Harbor* at Chicago in the early twentieth century. *Courtesy of the Library of Congress.*

Benton Harbor, Holland, and Ottawa Beach, all important shipping points and summer resorts along the Michigan coast." At 251 feet in length by 36 feet beam, and 1,300 tons, the *City of Benton Harbor* was the largest of the G&M line of steamers at the time.

The steamer *City of Chicago* ran on the St. Joseph route in connection with the *City of Benton Harbor*, and the steamers *Puritan* and *Holland* provided daily service on the Holland route. "During the fruit-shipping season the sight of these steamers entering the port of Chicago, laden to the very guards with thousands of baskets of peaches, is both surprising and instructive. It emphasizes the great wealth of the country along the Inland Seas."[121]

> *The steamer* South Haven *is a modern steel vessel, of dimensions two hundred and forty-seven feet keel, two hundred and sixty feet length of deck, by forty feet beam, and plies between Chicago and South Haven and Muskegon. It is a popular steamer among the resorters of the Michigan shore, and enters largely into the fruit transportation across Lake Michigan.*[122]

The most famous of the steamers run by the Indiana Transportation Company were the *Theodore Roosevelt* and the *United States*. "With broad open

This image shows the steamer *Theodore Roosevelt* on Lake Michigan. *Courtesy of the author.*

Early Twentieth-Century Steamers

decks providing wide promenades, [the *Theodore Roosevelt*] has a capacity of thirty-five hundred passengers, and is often taxed to the limit on her popular run [from Chicago] to Michigan City, Indiana, which is made twice daily." The steamship, built in 1906, featured engineering improvements including seven watertight compartments, double bottoms and trimming tanks to prevent listing, making the vessel "practically unsinkable."

Unusually large steam engines for her size gave the *Theodore Roosevelt* a reported speed of twenty-four miles an hour. The four-cylinder, triple-expansion engine was placed just aft of the midships section, and was thirty-two feet long by about twenty feet in height. The engine extended four feet above the main deck and was enclosed by a mahogany rail to allow passengers to watch its "smooth and steady motion."

> *The electrical equipment of the* **Roosevelt** *is most complete. Besides the thousand or more lamps, and the five thousand candle-power searchlight, high on the bridge deck, there are streamers of colored lights extending from stem to stern. Far above the hurricane deck between the smokestacks and outlined against the sky, is a huge sign Roosevelt, which may be read for some distance. At night each letter of flaming light stands out in bold relief, thus forming the name as a sort of beacon of hope and life.*[123]

The steamer *United States* was billed as "a patriotic craft of rare attractiveness." She had four decks accommodating 2,500 passengers comfortably, and "suspended electrical effects consisting of a streamer of red, white, and blue lights, an immense shield and star similarly lighted, the name of the ship, in twenty-four-inch letters, and the 'star-spangled banner' flashing on and off the Stars and Stripes in a waving effect." The interior of the vessel was no less patriotic, with pictures and paintings representing scenes from the history of the country and "handsome gold and silver lettered, cut-glass tablets bearing patriotic sayings of great men" lining the sides of the cabin.[124]

In 1910, James Cooke Mills boasted, "The highest type of water craft is the modern passenger steamer. It is the culmination of the shipbuilder's art. It represents the genius and skill of an army of steel workers, wood workers, and those of allied trades. Its interior reflects the taste and delicate touch of the artist and decorator. Its conveniences for the comfort and pleasure

Steamer *Eastland* capsized in the Chicago River on July 24, 1915. *Courtesy of the Library of Congress.*

of tourists and excursionists bent on business or recreation are everywhere present. And its mechanical being and safeguards of life are as nearly perfect as can be devised."[125] How disappointed Mr. Mills must have been when within the next five years the country was shocked by the egregious loss of life accompanying the disasters of first the Atlantic steamer HMS *Titanic*, and then the Lake Michigan steamship SS *Eastland*.

The capsizing of the passenger steamship *Eastland*, which caused the death of 812 people, occurred in the Chicago River at the Clark Street Bridge, in the very heart of the city of Chicago, about 7:20 on the morning of Saturday, July 24, 1915.

The ship was one of four that employees of the Western Electric Company had chartered to carry 7,000 men, women and children on an annual outing to Michigan City, Indiana. The excursionists began to arrive at the dock as early as 6 o'clock in the morning, wishing to sail on the first boat and make the day as long as possible. As soon as the gates were thrown open a solid line of people, two abreast, moved onto the *Eastland*, and by 7:10 there were approximately 2,500 people aboard. The passengers, largely women and children, were in high spirits. "The little ones were romping as well as they could on decks so crowded that one could scarcely walk, and the older ones were waving and shouting to their friends who were boarding the other boats."

With the boat filled, preparations were made to sail at once. One line had been cast off, and the boat was beginning to swing into the stream. The *Eastland* listed slowly over away from the dock, swayed back almost to an even keel, and then began to list again. "At first the people thought there was

Early Twentieth-Century Steamers

nothing unusual about the movement of the boat. It was not until the second listing had progressed so far as to overturn a refrigerator that the crowd became alarmed. Then the cheers and waving and shouts of glee gave way to cries of terror, and a mad panic ensued as hundreds of screaming and struggling men, women and children slid across the sloping decks, fought for room on the companionways, clutched companions, deck chairs, or any other object that came handy." The ship slowly turned over and lay flat on her port side in some eighteen feet of water, with the keel only a few feet from the dock.

A number of passengers on the starboard side of the boat, next to the dock, scrambled ashore or dropped into the water and were pulled out by rescuers. Several hundred, gathered on the upper or hurricane deck, were spilled overboard into the river, and swam ashore, or were saved by rescuers. But many of the hundreds between decks were penned in and drowned or crushed to death by shifting furniture. "Some of the imprisoned held on until holes were cut in the side of the boat which remained above water, and

One of the 812 victims of the SS *Eastland* disaster is carried away from the scene by rescue workers. *Courtesy of the Library of Congress.*

were taken out alive, but terribly shattered by the horror." Hundreds were dead when finally the rescuers reached them.[126]

> *News of the tragedy spread rapidly. The fire and police departments were called out; the river boats of both departments and other craft came to the rescue; scores of volunteer rescuers plunged into the work, and the task of taking the passengers from the boat and from the water where they had leaped or had been thrown, went on for hours. Some 1,700 reached shore alive, while the dead were already being laid in windrows along the bank.*[127]

Passengers of other steamers, river men, South Water Street employees, police, firemen and young men from the crowd were diving into the river and the hold of the steamer, occasionally bringing up "a body in which there was still a breath of life." On the sidewalks under the street awnings, partially protected from the rain, coatless physicians were trying to resuscitate

This photograph captures the rescue work in progress at the scene of the *Eastland* disaster in Chicago in 1915. *Courtesy of the Library of Congress.*

the victims who were being brought more rapidly than they could be cared for. Around the fringes of and through the large crowds, men, women and children who had been rescued were dazedly calling out for news of their friends and relatives who had been with them onboard. "All the while the dead were being brought up from the boat and carried across a tug which bridged the gap between the river bank and the side of the ill-fated *Eastland*."

Built in 1903 for the route between Chicago, Illinois, and South Haven, Michigan, in competition with the steamer *City of South Haven*, the *Eastland* had served several routes on the lakes and changed ownership three times prior to the accident in 1915.

Following the capsizing, the captain and first mate of the *Eastland* were arrested and an exhaustive investigation conducted. A number of factors were found to have contributed to the tragedy: The *Eastland* had always been top heavy and given to issues with listing. She was equipped with water ballast tanks so that she could enter the harbor of South Haven, Michigan, and other shallow ports and river mouths. When approaching such entries the water would be forced from the tanks, reducing the boat's draft. The ballast would be taken on again when the vessel emerged from the harbor. When partially filled, as they likely were at the time of the tragedy, the sloshing of water in the tanks added to the ship's lack of stability. Beyond this, the *Eastland* had recently been refit with poured concrete floors on main and 'tween decks to replace deteriorating wood flooring, thus adding as many as fifty-seven tons in top weight. She was also heavily loaded with passengers—not beyond her registered carrying capacity, but nonetheless, beyond what should have been common sense. Finally, in response to the La Follette Seaman's Act, which required sufficient lifeboats or rafts for everyone on board, the *Eastland*'s owners had added three life boats and six large life rafts, weighing a total of ten tons, to the upper deck of the vessel. This last, and most ironic factor, was likely the final insult to the ship's already questionable stability.

Another serious steamer accident of the period, the burning of the passenger steamship *City of Chicago* on Lake Michigan, had a very different outcome. On September 2, 1914, Captain Oscar Pjork was piloting his sidewheel steamer on the night run from Benton Harbor, Michigan, to Chicago with a full load of fruit and sleeping passengers when he was informed of a fire aboard his vessel while still twelve miles out from Chicago. Fearing a panic among the passengers, the captain chose not to immediately wake

them and ordered the ship to proceed at full speed toward their destination. The engineers and stokers worked in choking smoke from the fire but did not abandon their posts in the engine room. The wireless operator tried to send out an SOS but "could not raise a spark" with his equipment. However, ships at Chicago were alerted by the sight of the burning steamer coming in and several tugs and two excursion steamers got underway to assist. The passengers were notified of the fire once the Chicago pier was in sight, at which point "most of the passengers rushed to the upper decks, nearly all of them clad only in their night garments." The captain ran the burning ship aground on the breakwater, causing additional damage to the vessel, but saving the passengers and crew. The headlines of the next day read, "300 SAVED FROM BURNING STEAMER."[128]

A summation of the benefits of a journey by passenger steamship on Lake Michigan was provided by a travel publication in 1909. "And so it goes, from end to end of the Lakes, every mile fraught with interest, every hour offering the traveller something new of scenery or history. And this life of the Lakes is not, like that of the salt seas, open only to those of means. It is within the poor man's reach as well as the rich, is accessible to the hardworking housewife as well as to the woman who possesses her carriage and her servants."[129] To those sentiments, a caution might be added: no journey, regardless of the grandeur and technological prowess of the conveyance, can ever be considered truly free from risks.

CHAPTER 6

WAR ON THE LAKEFRONT

In each hand he held one of the longest, prettiest revolvers it was ever my fortune to see. The plans of the raiders included the capture of more than one steamer. They had the Philo Parsons, but they also wanted the Island Queen.
—Frederick Hukill

There is a recurring connection between the passenger steamships of Lake Michigan and the wars of the United States that begins with the story of the Black Hawk War and the first steamers to arrive at Chicago, and climaxes with the nearly forgotten military maritime activities on the Lake during World War II.

THE BLACK HAWK WAR

The Black Hawk War was a series of raids and military clashes between a group of Native Americans of the Sauk and Fox tribes, led by the leader Black Hawk, and white militias and federal troops of the United States. Black Hawk was an outspoken critic of the relocations of the Sauk and Fox, which had pushed them from their traditional home in the area of Rock River, Illinois, to less hospitable lands west of the Mississippi River. The relocation was designed to open lands for white settlers and their "superior civilization."

The relocation to untried growing areas coupled with the harsh winter of 1831–1832 caused hardship and starvation among the Sauk and Fox people,

The Lake Michigan steamer *Arrow*—before being condemned at Green Bay in 1863—shows the steamer design typical of the 1830s. *Courtesy of the Library of Congress.*

and, in April of 1832, Black Hawk left the main community and led a band of warriors and their families back to the Rock River area. Despite finding that much of their former homeland was now occupied by white squatters, they set about planting a crop of corn for the coming year. Black Hawk's warriors numbered only about 400, with the majority of the band made up of elders, women and children. Despite the multigenerational makeup of the group, their arrival in Illinois was sufficient to cause a state of near panic among the settlers and government officials of the area. Militia units were promptly called up and requests were made for U.S. troops to move against the threat of "encroaching Indians."

A.T. Andreas' 1884 *History of Chicago from the Earliest Period to the Present Time* gives this account of the feelings stirred among the settlers of the area by the news of Black Hawk's return:

> *Nothing was thought of or talked of except the danger that menaced the whites. Although no great fear was entertained for the safety of those within the garrison [Fort Dodge] from Black Hawk's band, a vague fear, an undefinable dread gave the settlers a continued anxiety, known only to those who have experienced it.*

War on the Lakefront

As soon as a militia force was formed and sent against Black Hawk and his people, the group abandoned their newly planted fields and fled. However, on May 13, the pursuing militia camped close behind Black Hawk's retreating band at a location about ten miles southwest of modern-day Rockford, Illinois. Black Hawk sent three emissaries under a white flag of truce to invite the militia leader to meet and discuss surrender. Despite the white flag, the militia troops fired on the natives, killing one of the messengers. The militia then attacked the Sauk–Fox camp in what became known as the battle of Stillman's Run. "In the ensuing battle, 40 Sauk warriors repulsed 275 militia, who fled in fear and confusion."[130] Black Hawk himself gave the following testament to the motivations for the war:

> *You know the cause of our making war. It is known to all white men. They ought to be ashamed of it. The white men despise the Indians, and drive them from their homes. They smile in the face of the poor Indian, to cheat him; they shake him by the hand, to gain his confidence, to make him drunk,*

Black Hawk (1767–1838), was a war leader of the Sauk and Fox tribes and outspoken critic of forced relocation of native people. *Courtesy of the Library of Congress.*

and to deceive him. We told them to let us alone, and keep away from us; but they followed on and beset our paths, and they coiled themselves among us like the snake.[131]

Further clashes between natives and whites flared up across northern Illinois and southern Wisconsin as armed groups of whites and natives, some only loosely associated with the principal forces, roamed throughout the countryside and took advantage of the chaotic and violent conditions to settle old scores. On May 20, a group of Pottawatomie attacked the white settlement at Indian Creek, massacring fifteen people. Men, women and children were killed, scalped and mutilated, and two teenage girls, Rachel and Sylvia Hall, were taken captive. This attack may have been unconnected to Black Hawk's band, which was on the run staying just ahead of the militia and army troops sent to suppress them.

The lack of a speedy conclusion to the conflict was embarrassing to President Andrew Jackson, who ordered General Winfield Scott to assume command of the war effort and put down the uprising. From his headquarters in New York City, General Scott called up hundreds of U.S. troops and chartered four passenger steamships to transport his army to the outpost of Fort Dearborn at Chicago. The steamships chartered were the *Henry Clay*, *Sheldon Thompson*, *William Penn* and *Superior*. Troops, including the forty-four members of the West Point graduating class of 1832, embarked on the steamers at Buffalo along with supplies for the campaign against Black Hawk. The passenger steamers set forth on July 3, but two days later, while on Lake Huron above Detroit, the small armada was stricken.

Captain Augustus Walker, commander of the steamer *Sheldon Thompson*, described the events that followed:

> *Owing to the fearful ravages, made by the breaking out of the Asiatic cholera among the troops and crews on board, two of those boats [*Henry Clay *and* Superior*] were compelled to abandon their voyage, proceeding no further than Fort Gratiot [Michigan]. The disease became so violent on board the "Henry Clay," that nothing like discipline could be observed, everything in the way of subordination ceased. As soon as the steamer came to the dock, each man sprang on shore hoping to escape from a scene so terrifying and appalling. Some fled to the fields, some to the woods, while*

others lay down in the streets, and under the cover of the river bank, where most of them died, unwept and alone.

There were no cases of cholera causing death on board my boat until we passed the Manitou Islands on Lake Michigan. The first person attacked died about four o'clock in the afternoon, some thirty hours before reaching Chicago. As soon as it was ascertained by the surgeon that life was extinct, the deceased was wrapped closely in his blanket, placing within some weights secured by lashing of small cordage around the ankles, knees, waist, and neck, and then committed with but little ceremony, to the deep. This unpleasant though imperative duty was performed by the Orderly Sergeant, with a few privates detailed for that purpose. In like manner twelve others, including this same noble Sergeant, who sickened and died in a few hours, were also thrown overboard before the balance of the troops were landed at Chicago. The sudden and untimely death of this veteran Sergeant and his committal to a watery grave caused a deep sensation on board among the soldiers and crews, which I will not here attempt to describe. The effect produced upon General Scott and the other officers, in witnessing the scene, was too visible to be misunderstood, for the dead soldier had been a very valuable man, and evidently a favorite among the officers and soldiers of the regiment.[132]

Under any other circumstances, the arrival of the first steamship to Chicago would have occasioned considerable celebration among the local populace. However, for settlers already on edge over the fear of hostile Indians, the news of pestilence arriving at their door was too much to be endured. A.T. Andreas provided the following account of the inglorious welcome received by the *Sheldon Thompson* at Chicago:

On the evening of July 10th the steamer "Sheldon Thompson," commanded by Captain A. Walker, arrived from Buffalo, having on board General Scott, his staff, and four companies of troops. The news of their arrival was accompanied with the intelligence that the dreaded scourge of Asiatic cholera was on board, in such violent type as to have already decimated the troops on the voyage. It required no direct orders from either General Scott or Major Whistler to make room in the garrison for the newly arrived troops. The sojourners who, a few weeks before, had fled from the

This illustration portrays Fort Dearborn. *Courtesy of the Library of Congress.*

> *Indians, now fled with more precipitate haste and terror from the deadly pestilence that had entered their place of refuge. By the 12th the village was virtually depopulated and given over to the sick, the dying, the dead, and those whom duty compelled or humanity urged to remain to minister to them. The garrison became a hospital. There was no thought on the part of General Scott to make any aggressive move or to take any part in the campaign against Black Hawk until the disease should cease its ravages. Eight days later on July 18th the steamer "William Penn" arrived with Government stores and a further detachment of cholera-stricken soldiers. The flight of the inhabitants and sojourners confined the ravages of the pest to the soldiers and the officers with their families. It is impossible in words to depict the horror of the time. During the ten days succeeding General Scott's arrival a hundred dead soldiers were silently carried without the gates of the garrison and hastily laid to their final rest, in a common grave, without coffin, or other shroud than the soldiers' blanket in which each had gone to his last sleep.*[133]

Captain Walker, having landed General Scott and his staff, stayed at anchor through the night of the 10th and gave the following report of the activities of the next few days:

War on the Lakefront

Before landing the troops next morning, we were under the painful necessity of committing three more to the deep, who died during the night, making, in all, sixteen who were thus consigned to a watery grave. These three were anchored to the bottom in two-and-a-half fathoms, the water being so clear that their forms could be plainly seen from our decks. This unwelcome sight created such excitement, working upon the superstitious fears of some of the crew, that prudence dictated that we weigh anchor and move a distance sufficient to shut from sight a scene which seemed to haunt the imagination, and influence the mind with thoughts of some portentous evil.

We remained four days after landing the troops, procuring fuel for the homeward voyage, etc. The only means of obtaining anything for fuel was to purchase a roofless log-building used as a stable. That, together with the rail fence enclosing a field of some three acres near by, was sufficient to enable us to reach Mackinaw. Being drawn to the beach and prepared for use, [the wood] was boated on board by the crew, which operation occupied most of four days to accomplish. During this protracted stay the crew became quite uneasy to get under way, and leave behind them a scene fraught with associations of the dead and dying, which they had witnessed so frequently, until they became almost mutinous. But as soon as orders were given to get under way, the celerity with which the yawl was hoisted to the stern was a scene of exciting interest, as the duty was performed with a will and a spirit of cheerfulness, accompanied with a hearty song of 'Yo-heave-ho'. As they hove at the windlass, they seemed almost frantic with joy when the anchor came in sight and her prow turned homeward.[134]

The Black Hawk War was not yet done, but the part to be played by Lake Michigan passenger steamships was complete. On July 21, 700 troops under the command of Colonel Henry Dodge of the western Michigan territory militia were held off by sixty Sauk warriors during the battle of Wisconsin Heights, allowing the Indian noncombatants to cross the Wisconsin River to temporary safety. That same day, another offer of surrender was ignored by Dodge's forces, and the bloody end of the short conflict came with the massacre at Bad Axe on August 1 and 2 of 1832. Black Hawk's band—exhausted and having already lost many of the oldest and youngest members to starvation and deprivation—had reached the Mississippi at the mouth of the Bad Axe River, between modern-day Prairie du Chien and

LaCrosse, Wisconsin. While they were preparing to cross the river, they were discovered by the newly built river steamboat *Warrior*, which had been chartered a few days earlier by the U.S. Army. Black Hawk, waving a white flag, once again attempted to surrender, and once again the peace signal was ignored as soldiers aboard the *Warrior* opened fire with small arms and cannon, indiscriminately killing twenty-three amid cries of "Remember Indian Creek!"

After the *Warrior* withdrew, Black Hawk and his closest supporters continued upriver; however, most of the band camped in order to again attempt to cross the river the next morning. On August 2, federal troops and militia—the latter under the command of Henry Dodge—overtook and attacked the remnants of the band as they attempted the river crossing. Over an eight-hour period, soldiers slaughtered fleeing Indian men, women and children. At about 10 a.m., the steamer *Warrior* returned and added its cannon to the slaughter. The war was over.

The Civil War

There is an interesting and little-known piece of Civil War history that is directly connected with the passenger vessels of the Great Lakes and the USS *Michigan*, the first iron-hulled warship in the U.S. Navy and the only U.S. warship stationed on the Great Lakes during the Civil War.

Launched in Lake Erie in December of 1843, the *Michigan* was charged with patrolling the Great Lakes to promote stability and to protect lake shipping. Although originally intended to protect the interests of the United States against potential aggression from Canada, by the time of the Civil War the most obvious threat to shipping on the lakes had become the Confederacy.

In secret sessions during February 1864, the Confederate Congress passed a bill that authorized a campaign of sabotage against "the enemy's property, by land or sea." The bill established a Secret Service fund of US$5 million to finance the sabotage. A Confederate operative, Captain Thomas Henry Hines, was given orders by the Confederate War Department that empowered him to carry out "any hostile operation" that did not violate Canadian neutrality. Hines and other conspirators planned to "create a

revolution" within certain Union states by raising an insurrection from bases in Canada, then officially known as British North America.

The conspirators mainly recruited sympathizers from Ohio, Indiana and Illinois, where an estimated 40 percent of the population was Southern born. Many belonged to secret societies, such as the Knights of the Golden Circle or the Order of the Sons of Liberty, which were anti-Union and anti-abolition. Members wore on their lapels the head of Liberty, cut from copper pennies. Their enemies called them Copperheads for the poisonous snake that struck without warning.

Not far from the Canadian border were two large Union prisoner of war camps; one was on Johnson's Island, near Sandusky, Ohio, in Lake Erie, and the other at Fort Douglas in Chicago. To enlist soldiers for the insurrection, the conspirators came up with an elaborate plan: agents would slip out of Canada, take over Great Lakes passenger steamers and use them as impromptu warships for the boarding and seizure of the USS *Michigan*. The Confederates would then attack Johnson's Island, free the thousands of prisoners there and arm them. In coordinated raids, prisoners at Fort Douglas would also be freed and armed. The Confederate soldiers, allied with the Sons of Liberty, would then take over the region, forcing the North to sue for peace.

On September 19, 1864, John Yates Beall, a veteran blockade runner, and about twenty men boarded the *Philo Parsons* at Detroit as ordinary

USS *Michigan*, built 1843, was the U.S. Navy's first ironclad warship and first on the Great Lakes. *Courtesy of the Library of Congress.*

passengers. The *Philo Parsons* was a small passenger steamer that normally served the Detroit–Sandusky route. At Beall's request, the captain of the steamer made an unscheduled stop at Amherstburg on the Canadian side of the Detroit River, and several more of Beall's men boarded, toting a large trunk filled with grappling hooks for seizing the *Michigan*.

As the *Philo Parsons* neared Johnson's Island, Beall put a pistol to the helmsman's head and took over the ship. Frederick Hukill, a passenger aboard the captured steamer, later related his impressions of the unexpected act of piracy:

> *To look up from a peaceful cigar and behold a sixteen inch revolver pointed at one's head, to be metamorphosed from a tourist into a prisoner of war in the twinkling of an eye, to argue vainly with short spoken men bristling with eloquent firearms, and finally to be marooned—such incidents are crowded when brought within the limits of a few hours.*[135]

Beall then set out to detain and capture another passenger steamer, the *Island Queen*, which happened to have on board a company of unarmed Union soldiers on leave, who, surprised by the sudden appearance of Confederate pirates, surrendered without a struggle. Next, the passengers of both vessels—now numbering 105—were marooned on a small island while Beall with his two prizes steamed to a point off Johnson's Island and awaited a signal from accomplices aboard the *Michigan*.

According to the Confederate plan, a Philadelphia banker and new friend of the captain of the *Michigan* was supposed to signal Beall that all was clear for the attack after having drugged the ship's officers during a dinner party aboard the vessel. However, the supposed banker, who was really Captain Charles H. Cole of the Confederate Army, had been arrested by Union soldiers. Union records show that Cole, captured on a tip from a Confederate captive and held aboard the *Michigan*, "disclosed the whole plot" in time for the Union warship to prepare for battle. Seeing no signal and rightly fearing that the *Michigan* had been alerted, Beall's crew, murmuring mutiny, demanded that he abort the attack. Beall scuttled the *Island Queen*, set course for Canada, landed everyone ashore and burned or scuttled the *Philo Parsons*.

The next Confederate plot to be attempted was the release of Confederate prisoners from Fort Douglas at Chicago. The pirating of passenger steamers

from that city to convey the newly formed army was also considered, and, if successful, would have placed improvised Confederate "commerce raiders" on Lake Michigan.

Colonel Benjamin J. Sweet, commander of the POW camp at Fort Douglas, knew there was trouble brewing. In a dispatch to his commanding officer, he reported that Chicago "is filling up with suspicious characters, some of whom we know to be escaped prisoners, and others who [are] here from Canada." With only 800 men to guard roughly 9,000 prisoners, Colonel Sweet was justifiably nervous. The prisoners were demonstrating restlessness, having heard—like Sweet—rumors of insurrection, prison-camp breakouts and an invasion of Chicago. Through double agents, the colonel learned the plans of the conspirators, which he later reported:

> *They intended to make a night attack on and surprise this camp, release and arm the prisoners of war, cut the telegraph wires, burn the railroad depots, seize the banks and stores containing arms and ammunition, take possession of the city, and commence a campaign for the release of other prisoners of war in the States of Illinois and Indiana, thus organizing an army to effect and give success to the general uprising so long contemplated by the Sons of Liberty.*[136]

The steamer *Chicago*, seen in this illustration by Samuel Ward Stanton, was typical of the side-wheel passenger steamships on Lake Michigan during the Civil War. *Courtesy of the Library of Congress.*

A preemptive raid by Colonel Sweet and Union Army agents on November 7, 1864, led to the arrest of the leaders of the conspiracy and the officers of the Sons of Liberty, along with "106 bushwhackers, guerrillas, and rebel soldiers." Also discovered in a collaborator's home near the prison camp was a weapons cache of 142 shotguns and 349 revolvers, along with thousands of rounds of ammunition.

Still later in the year, the gunboat *Michigan* was called upon to intercept the passenger and freight steamer *Georgian*, which had been purchased by Confederate agents in Canada with the intention of carrying out "raiding expeditions against the United States of America." In particular, it was later reported that the Confederates had planned to arm the *Georgian* with "torpedoes, hand-shells, Greek fire, and other explosive missiles"[137] and strengthen her bow for use in ramming U.S. commercial and fishing vessels.

The news of another renegade steamer loose on the upper lakes spiked public anxiety to levels of near panic and caused disruptions to shipping without a shot ever being fired by the *Georgian*. Commander John C. Carter of the *Michigan*, was called upon to waylay the *Georgian* on any pretext. In reference to the expectation that the *Michigan* was a source of reassurance to the public during the uncertain times of the War Between the States, Commander Carter reported: "I found the people suffering under serious apprehensions. The presence of [the *Michigan*] perhaps did something to allay the apprehensions of the excited, doubting people."

Spanish-American War

The Spanish-American War, lasting April to December of 1898 between the United States and Spain, was declared on the part of the U.S. Congress ostensibly to ensure the independence of Cuba, which was the primary focal point of the conflict.

At the time, the United States had a standing army of just 28,000 regulars and a small but reportedly well-trained navy. President McKinley seized the initiative in the short war by blockading the Cuban coast and moving troops to the island at the earliest possible opportunity. Besides the regular army troops that required transport to Cuba, there was also a growing number of volunteer units being formed. To meet the immediate need for transport

and auxiliary ships, over fifty Great Lakes schooners and small steamers were purchased or chartered by the U.S. government for service on the East Coast and the Caribbean.[138] At least two of these steamships were of sufficient size to require being "cut in two" in order to get through the canals to the East Coast.[139]

Most of the vessels purchased were hurriedly modified to carry troops, and in some cases, cavalry horses. Water tanks and electrical systems were upgraded, and fans were added for ventilation. Galleys designed for smaller numbers were expanded to handle the feeding of great quantities of soldiers.

The greatest test of these impromptu transportation efforts was in the Cuban campaign, where tens of thousands of combatants required transport on relatively short notice. Though militarily uneventful, the crossings from Tampa, Florida, to Cuban ports were often uncomfortable with soldiers frequently crowded below decks in sweltering conditions.

The massive troop transfer effort was ultimately termed "chaotic but successful," in part due to the added flotilla of passenger steamers secured from Lake Michigan and other Great Lakes. Few, if any, of the steamers purchased or chartered for the war effort returned to service on the lakes after the close of the war.

World War I

World War I, 1914 to 1918, was one of the largest wars in history. The conflict involved over 70 million military personnel and most of the great powers of the time. The United States was a late entrant into the war, having maintained neutrality until April 6, 1917. Once war was declared, however, the small American army quickly swelled to over 4 million men with the implementation of a new draft, and by the summer of 1918 the United States was sending 10,000 soldiers a day to bolster the Allied war effort in France.

Just like the Spanish-American War, the sudden need for large numbers of troop and support ships caused the government to look to Great Lakes shipping. In 1917, a number of passenger steamers were commandeered for military service, including well-known Lake Michigan vessels such as the *Theodore Roosevelt*, *Puritan*, *Virginia*, *City of South Haven*, *Nevada*, the first *E.G. Crosby*, *Minnesota* (formerly *Harlem*) and the infamous *Eastland*.

The commandeering of passenger steamships, many of them reliable workhorses immediately missed by the transportation companies from which they were obtained, was not a matter for rejoicing on the part of the ship owners. However, any complaints were likely made in private as national temper was running high; government propaganda was in full vigor, and criticism of the war effort was seen as nearly criminal.

The United States Shipping Board was the government entity charged with the task of assembling and maintaining a merchant fleet for war purposes. Edward N. Hurley, chairman of the board during World War I, gave this account of the importance of steamships taken into national service from the Great Lakes:

> Confronted with a desperate shortage of tonnage, we found a valuable source of shipping on the Great Lakes. We commandeered an extensive tonnage of Lake vessels, re-fitted them for ocean service and brought them down to the sea-board.
>
> Twelve of these ships were too large to pass through the Welland Canal and the novel method of bisecting them while afloat was employed. The hulls were cut squarely amidships, the parts were sealed by watertight bulkheads, and the sections were taken through the canal. In some cases the rear half of the ship was sent under its own steam, stern first, while the forward half was towed. Some of the largest boats had to be turned on the side and towed on pontoons specially constructed. The rejoining was done for the most part in dry dock. Sixty-four requisitioned or purchased vessels had been brought down from the Lakes by the time the armistice was signed.[140]

The SS *Virginia* was one of the Great Lakes vessels found to be too large to transport to the East Coast intact and was bisected, as described by Chairman Hurley, in order to fit through the Welland Canal. Commissioned by the Goodrich Transportation Company for the night route between Chicago and Milwaukee, the *Virginia* was built at the Globe Iron Works in Cleveland, Ohio, in 1891 at a cost of $251,550. Even before beginning regular service, the *Virginia* was causing excitement, according to the *Grand Haven Evening Tribune*:

War on the Lakefront

USS *Blue Ridge*, formerly SS *Virginia*, is shown with its bow cut off for passage out of the Great Lakes in 1918. *Courtesy of the Department of the Navy—Naval Historical Center.*

> *The new Goodrich line steamer,* Virginia, *is creating quite a flurry of excitement in Milwaukee where she is being fitted out for the west shore line. She's a beauty. By the courtesy of the Goodrich Transportation Co's local agent we are in receipt of the Marine Review containing an illustration and description of the* Virginia, *the most elegantly appointed passenger steamship built on any inland water, and the finest ship that flies the American flag. She will leave Chicago at 9 o'clock each morning, and including the stop at Racine will make the trip to Milwaukee in five hours.*[141]

The *Virginia* saw extensive service on Lake Michigan from 1891 until her acquisition for war use in 1917. In 1910, she ran a regular route between Chicago, Grand Haven and Muskegon and was described by author James Cooke Mills:

> *The* Virginia *is fitted up as a night boat, providing every comfort for travellers. She is two hundred and eighty five feet in length, thirty-eight feet beam, and registers sixteen hundred gross tons. The* Virginia *runs night trips between Chicago, Grand Haven, and Muskegon along with the steamer* Indiana *which, though smaller of dimensions, is one of the popular steamers on Lake Michigan.*[142]

In early 1918, the *Virginia*'s bow was removed for transport through the Welland Canal on her way to the East Coast, where she was outfitted as

125

SS *Virginia* (later USS *Blue Ridge*, 1918–1919) is seen in Muskegon, Michigan. *Courtesy of Department of the Navy–Naval Historical Center.*

a troop transport at the Boston Navy Yard. Renamed the USS *Blue Ridge*, the steamer was placed in commission on October 17, 1918, the same day that began the final Allied push toward the German border, which lead to the war's end on November 11, 1918. Work on the ship was not completed before the armistice, and the *Blue Ridge*—incomplete in her refurbishment for war service—was no longer needed by the navy. Her name was struck from the navy list on July 7, 1919.[143]

The passenger steamship *City of South Haven* was launched March 23, 1903. Built in Toledo, Ohio, for the Dunkley-Williams Steamship Company, the ship was intended for the lucrative day-night fruit and passenger route between Chicago, Illinois and South Haven, Michigan. Destined to compete on this route with another new steamer, being built by the Michigan Steamship Company, the challenge between the two ships began even before either was launched. Both companies wanted to use the name *City of South Haven*, and a compromise was reached: the first to launch would gain the name. The competing steamer, launched on May 6, 1903, settled for the name *Eastland*.

War on the Lakefront

This page: These photographs show three views of SS *City of South Haven*. The ship is also seen in dry dock, painted in a World War I camouflage pattern following conversion to the USS *City of South Haven*. *Courtesy of Department of the Navy–Naval Historical Center.*

A *New York Tribune* article on March 20, 1903, claimed, "The *City of South Haven* will be equipped with wireless telegraph apparatus and a plant for publishing a small newspaper. It is promised that the new steamer will be the fastest on the lakes. The contract calls for a speed of not less than twenty miles an hour." It might be noted that her soon-to-be launched competitor, the *Eastland*, was able to claim a top speed of twenty-two miles per hour, winning her the title, Speed Queen of the Lakes.

The *City of South Haven* served regular routes on southern Lake Michigan for the next fifteen years before being commandeered by the navy and sent to Chicago for conversion into a troop ship. Commissioned into the navy just two days before the November 1918 armistice, the ship, now the USS *City of South Haven*, was sent to Boston, Massachusetts, to continue preparations for European service. However, the ship never made a transatlantic crossing and was sold out of the navy in 1919. Renamed the *City of Miami*, the steamer served a route between Miami and Cuba before being returned to Lake Michigan in 1923 under the name *E.G. Crosby*, where she continued until

Steamer *Eastland* is seen in South Haven, Michigan, sometime between 1903 and 1905. *Courtesy of the author.*

laid up in 1931. The ship suffered massive damage in a fire on December 3, 1935, while idled at Sturgeon Bay, Wisconsin, and was scrapped in 1942.

Most Great Lakes passenger steamships taken into military service were intended, not surprisingly, for use as troop transports or, as in the case of the *SS Minnesota*, hospital ships. One notable exception is the *SS Eastland*. Re-floated on August 14, 1915, following her disastrous capsizing on the Chicago River, the *Eastland* was taken over by the Central Trust Co. of Illinois, from which it was acquired by the navy on November 21, 1917. Renamed *USS Wilmette* on February 20, 1918, the vessel was converted into a gunboat. Like many other converted Great Lakes vessels, the *Wilmette* was too late to see overseas service in World War I. However, unlike the *City of South Haven* and others, the *Wilmette* did not return to civilian service following the war. Instead she served as a training ship for naval reservists, carrying trainees assigned to her from the Great Lakes Naval Station in Illinois. Captain Edward A. Evers served as commanding officer of the Illinois naval militia from 1909 to 1941 and was instrumental in the effort to secure and convert the *Eastland*.

War on the Lakefront

When the steamer Eastland *capsized the Navy Department was prevailed upon to purchase her and convert her into a gunboat for training purposes. Experts from Washington were ordered to Chicago to make a thorough examination of the ship and reported that the scheme was feasible. The result was that the* Eastland *was converted into a gunboat and is now known as the USS* Wilmette.[144]

Though never engaged in combat, the *Wilmette* was used for live fire exercises and was likely the last US warship to sink a World War I vintage U-boat. On June 7, 1921, the *Wilmette* participated in the gunfire sinking of the former German submarine *UC-97* on Lake Michigan.

UC-97 was a mine-laying submarine laid down in late 1917 at Hamburg, Germany, and launched on March 17, 1918. She was never in action during the war and was surrendered according to the terms of the armistice. Early in 1919, the submarine was sent with an American crew to the United States along with five other captured German U-boats for promotional purposes connected with a Victory Bonds campaign. The *UC-97* traveled through the many locks of the St. Lawrence Seaway and entered the Great Lakes where she was taken on a whirlwind tour of American ports on Lakes Ontario, Erie,

German submarine *UC-97* is seen near the docks in Toronto with a steam tug alongside and a side-wheel passenger steamer at left, circa 1919. *Courtesy of the National Archives of Canada.*

Huron and Michigan. At the end of her tour, *UC-97* returned to Chicago where her crew turned the boat over to the commandant of the Ninth Naval District. She was laid up at the Great Lakes Naval Station until June 7, 1921, when she was taken out into Lake Michigan to be sunk as a target during naval reserve gunnery drills.

Manning the guns of the *Wilmette* were gunner's mates J.O. Sabin and A.F. Anderson. Sabin had fired the first American shell in World War I, and Anderson was the sailor to fire the first American torpedo of the war. The sinking itself, and the choice of gunners, was almost certainly calculated to produce more publicity and sell more Victory Bonds, and newspapers across the country carried articles about the event.

> *The first shot at an enemy craft in 117 years on the Great Lakes, was fired in Lake Michigan near Chicago, when the destroyer* **Wilmette** *turned her guns on the German submarine C-97, which was assigned to the United States by the terms of the armistice. Thirteen shots were fired altogether, but one would have been sufficient, as the first shot, fired by the same boy who fired the first American torpedo in the late war, was a direct hit.*[115]

While the article from the *Woodville Republican*, above, incorrectly calls the gunboat *Wilmette* a destroyer, even more interesting is the startlingly inaccurate article published in the *New York Times* on June 8, 1921, the headline of which claimed "GERMAN SUBMARINE SUNK IN LAKE MICHIGAN; U-97, Which Torpedoed Seven Allied Ships, Is Destroyed by Salvo From the *Wilmette*." The article went on to report:

> *The German submarine U-97 was sunk this morning in Lake Michigan some thirty miles off Chicago by the four-inch guns of the United States steamer* **Wilmette**. *The U-boat, with a known record of seven allied ships sunk, was destroyed in accordance with provisions of the Treaty of Versailles.*
>
> *The U-97 sank in 50 feet of water less than one minute after the first salvo of thirteen shots hit her. Before the* **Wilmette** *could wheel around to deliver another volley the former sea raider had disappeared.*

War on the Lakefront

The gunboat USS *Wilmette* (formerly SS *Eastland*) is seen on Lake Michigan. *Courtesy of the Department of the Navy—Naval Historical Center.*

Wilmette continued to carry out her reserve training mission until she was placed "out of commission, in service," on February 15, 1940. It was a brief respite; on February 17, 1941, she was designated *IX-29* and returned to training duty at Chicago on March 30, 1942. This time the ship's mission was to prepare guard crews for duty, manning the guns for armed merchantmen venturing across the wartime Atlantic. This assignment continued until the end of World War II in Europe signaled a return to transatlantic merchant shipping that was free from the threat of German U-boats.

In his book, *Home Country*, Ernie Pyle, a legendary war correspondent of World War II and a former naval reservist, described his experience aboard the USS *Wilmette*:

> *We sailed on the USS* Wilmette, *formerly known as the* Eastland. *It was the ship that turned over in the Chicago River in 1915 and drowned eight hundred twelve people. When it was raised, the Navy bought it and painted it gray and filled it full of innocent farm boys who wanted to be sailors. It was still in a sinking condition, I assure you. It constantly shied to the right, and once in a while felt as though it wanted to lie down in the water.*[146]

It was widely rumored that the USS *Wilmette* played host to President Franklin Delano Roosevelt and other dignitaries in August of 1943 for a secret "ten day cruise of McGregor and Whitefish Bays to plot war strategies." However the truth is less romantic: the president's visit to Lake Huron was indeed secret, the USS *Wilmette* was there and FDR was heavily guarded; however, the trip "was purely and simply a vacation," a fishing trip for President Roosevelt. "The USS *Wilmette* sat offshore throughout the visit, and 28 of her sailors took the fishermen wherever the fish were supposed to be biting."[147]

On November 28, 1945, after forty-two years of mixed service on Lake Michigan, the ship was decommissioned, and, in December of 1945, her name was struck from the navy list. On Halloween the following year, she was sold to the Hyman Michaels Co. for scrapping, ending a long career replete with tragedy and proud service.

World War II

Like foreign wars before, World War II created a huge and immediate demand for additional shipping. A part of this demand was met by shipbuilding companies in Manitowoc, Wisconsin, and other Great Lakes ports, and, once again, passenger steamers were pressed into service. However, a new and entirely unique opportunity for Great Lakes passenger steamships to serve the war effort was realized on Lake Michigan due to the overwhelming importance of airpower in this new conflict.

Even before the entry of the United States into World War II, President Franklin Delano Roosevelt had expressed his conviction that airpower was going to be key to American success should the country go to war. Nothing could have underscored that conviction more powerfully than the Japanese carrier-launched attack on Pearl Harbor on December 7, 1941. Following the attack, there could be no question as to the tremendous importance of airpower and aircraft carriers in the Pacific, as well as the need for pilots trained in carrier operations.

The problem was how and where to train thousands of new pilots to land and take off from aircraft carriers when the United States had only seven operational carriers in late 1941. With so few carriers, none could be

spared for training purposes. And even if carriers had been available for training, it was felt that it would invite attacks by U-boats or the Japanese if the great ships were paraded up and down the eastern or Pacific seaboards. The answer to the conundrum had been suggested months before the attack on Pearl Harbor by Commander Richard R. Whitehead, an aviation aide at the navy's Great Lakes Training Center; his solution was to convert existing Great Lakes passenger steamships into training aircraft carriers, operating them on the Great Lakes to keep them safe from enemy attack. At the time, nobody listened; but his idea gained currency after the airstrike on Pearl Harbor and eventually came to the attention of Admiral Ernest J. King, chief of naval operations. It was King who greenlighted Whitehead's concept.

A survey was made of available ships, and the navy purchased two of the largest passenger steamships on the lakes, the Cleveland & Buffalo

The grand side-wheel steamer *Seeandbee* (later USS *Wolverine*) at dock in Detroit, circa 1930. *Courtesy of the author.*

Transit Company's *Seeandbee* and the *Greater Buffalo*, owned by the Detroit & Cleveland Navigation Company. Both of the ships chosen for the program were designed by famous maritime architect Frank E. Kirby, who counted among his many designs four of the largest side-wheel passenger steamships ever built: the *City of Detroit III*, *Seeandbee*, *Greater Buffalo* and *Greater Detroit*.

The *Greater Buffalo* and *Greater Detroit* were identical sister ships built over a period of two years at a cost of $3.5 million each, an amount equal to about $44 million each in today's dollars. The two ships were the largest passenger ships on any inland waters at the time and the largest true paddle-wheel steamers ever built. With lavish interiors designed in a Renaissance style, each ship had more than 1,500 berths across their four passenger decks. The promenade deck held the main saloon, which extended though two decks with ornate galleries on either side providing access to the staterooms. The *Greater Detroit* was also reportedly considered for the training carrier program following the *Seeandbee* and *Greater Buffalo*, but this did not materialize.

When initially placed into service in early 1913, the *Seeandbee* was the largest and most costly steamship plying any inland waterway in the world. Boasting four passenger decks, four towering smokestacks, 510 staterooms and 24 lounges, the *Seeandbee* was a 500-foot-long Edwardian palace. Passengers entered on the main deck, which held a lobby, pursers' and stewards' offices, the ship's telephone switchboard, the checkroom and the huge main dining room. Three decks of staterooms and parlors were to be found above the main deck, and at the ship's center was a grand saloon with an impressive vista three decks high. The steel-hulled, mahogany and ivory finished side-wheeler could accommodate 1,500 passengers in style on the Cleveland–Buffalo route, with special cruises to additional ports such as Detroit and Chicago. The ship operated profitably as a night boat until 1932, but diminished travel during the years of the Great Depression forced the company to file for bankruptcy in 1937. In 1939, the *Seeandbee* was sold to the C&B Transit Co. of Chicago, where it operated on a regular schedule through 1941.[148]

Sold to the U.S. Navy in March of 1942 for $756,000, the *Seeandbee* was designated "unclassified miscellaneous auxiliary, IX-64" and taken to Cleveland, Ohio, where, on April 14, workers began removing the passenger steamship's ornate wood and steel upper decks. Transferred to Buffalo, New

This photograph shows USS *Wolverine* (formerly SS *Seeandbee*) near Chicago on August 22, 1942. *Courtesy of Department of the Navy—Naval Historical Center.*

York, the hull was turned over to the American Shipbuilding Company on May 6 where 1,200 workers labored around the clock to do what no one had ever done before: create an aircraft carrier from a steam-powered, side-wheel passenger ship.

The Auxiliary Vessels Board had recommended a flight deck of at least 500 feet in length for the training carrier; hence a huge steel framework was constructed above the 500-foot-long hull to support a 550-foot-long flight deck of 3-inch-thick Douglas fir. Wooden flight decks were typical for aircraft carriers of the day, but coal-burning steam engines were not. The ship's four smokestacks were reengineered so venting of the thick coal smoke could be achieved through a superstructure on the starboard side. This *island* also housed the navigation bridge, observation tower and communications equipment. An eight-wire arresting system was installed for landings, but no takeoff catapult. Designed to house 270 officers and crew, the vessel included officers' quarters, a wardroom and crew quarters on the main deck, as well as a flight instruction room, laundry, tailor shop, barber shop, ship's store, recreation room and galley.

The conversion was completed in just three months at a cost of $1,935,343—a Herculean feat by any standards. Commissioned at Buffalo on August 12, 1942, the newly named USS *Wolverine* steamed to Chicago to start flight operations on Lake Michigan on August 22, 1942.

On May 26, 1943, the USS *Wolverine* was joined by the newly commissioned USS *Sable*. The *Sable* had been converted from the side-wheel steamship SS *Greater Buffalo* at Buffalo, New York, by the American Shipbuilding Company; it was the same firm that had originally built the passenger steamer at Lorain, Ohio, for the Detroit & Cleveland Navigation Company in 1923.

Like the *Wolverine*, the *Sable* when completed included a small island on the starboard side containing the ship's redirected smokestacks, navigation bridge and observation tower. Her flight deck was longer than the *Wolverine*'s, and, as an innovation, the *Sable* had a steel flight deck checkerboarded with eight different nonskid coatings, making the *Sable* the first steel-decked carrier in the U.S. Navy.

THE NAVY'S NEWEST AIRCRAFT CARRIER: Buffalo, May 8, 1943—The Greater Buffalo, one of the largest passenger steamers on the Great Lakes, was commissioned the U.S.S. Sable today in colorful ceremonies and put in service as the Navy's second inland training aircraft carrier.[149]

A fighter lands on the USS *Sable* on Lake Michigan, with the inset showing a FM-2 Wildcat fighter on *Sable*'s deck after a barrier crash in May 1945. *Courtesy of the Department of the Navy Naval Historical Center.*

War on the Lakefront

The "inland training aircraft carriers" as the *New York Times* called them, were frequently referred to by others as the Great Lakes Navy or the Corn Belt Fleet. Whatever they were called, they were on Lake Michigan to do a serious job, with a goal of helping to train 45,000 Navy pilots.[150] Naval aviators started their training at basic flight schools in Florida and Texas and then were shipped to an advanced flight school at the Glenview Naval Air Station, twenty-five miles northwest of Chicago. This station was the point of departure for all aircraft engaged in freshwater carrier training operations. By the end of World War II, 15,000 carrier pilots had been trained at Glenview, along with 9,000 primary aviation cadets. "We were only there for about three days," recalls a career naval aviator who qualified in 1943 at age eighteen. "We spent a couple of days practicing approaches to the training field, and when our instructor felt we were ready, he sent us out to the carrier."

The Chicago-based training carriers were berthed near Navy Pier and steamed out onto Lake Michigan for flight operations, some of which took place less than a mile offshore. It has been reported that the sight of Avengers, Corsairs and Hellcats landing and taking off from the carriers caused traffic jams on Chicago's Lake Shore Drive as people stopped to watch. About 300 landings and takeoffs were made from each ship, every day, weather permitting. Weather permitting seems to have meant "as long as the aircraft were able to fly" since the ships executed their training mission until ice was too thick to allow them onto the lake, even with the assistance of Coast Guard icebreakers to extend their operational season.

> *Although the inexperienced pilots did not have to contend with the pitch and roll of a carrier at sea, they often had to deal with limited visibility due to snow, unpredictable gusts and those ever-present clouds of coal smoke. Cockpit canopies were required to remain open during takeoffs and landings, to allow for a pilot to escape a sinking plane. Cold winter winds whipping into a cockpit presented another hazard they would not experience, once qualified as naval aviators and sent to the Pacific. In addition, the training carriers' flight decks were only 27 feet above the water, significantly reducing the margin of error when approaches were being made.*[151]

Among the thousands of young navy pilots who completed carrier training with the assistance of the Corn Belt Fleet was former president

George H.W. Bush. In 1943, the twenty-year-old Lieutenant Bush, flying an Avenger, made six carrier landings and six deck run takeoffs from the *Sable* in a little more than two hours.[152] President Bush later recalled, "I remember those Great Lakes flights very well in the open cockpit that winter. Coldest I ever was in my life."

In order to qualify, a pilot had to make several successful landings and takeoffs on one of the training carriers. A number of aircraft crash-landed or had other mishaps. It has been estimated that nearly 150 planes found their way to the bottom of Lake Michigan during training accidents. The number of pilots killed during training accidents is more exact: eight. All the others, who found themselves in the frigid waters of Lake Michigan following a landing or takeoff gone bad, were rescued by vigilant Coast Guard crews using two winterized powerboats that shadowed *Wolverine* and *Sable*.

My first carrier landing came aboard the USS Sable *on November 28th, 1944. Each naval aviator candidate was required to complete eight successful landings. A successful landing meant that one didn't crash on*

A fighter plane leaves the deck of the USS *Sable* and is about to crash into Lake Michigan, circa 1944. *Courtesy of Department of the Navy–Naval Historical Center.*

the flight deck or land in Lake Michigan. I flew upwind on the starboard side of the carrier with the canopy open to the freezing wind and my nerves stretched pretty thin. As I passed the **Sable***'s bow, I snapped the aircraft into a hard 180-degree port turn. I lowered the wheels, flaps, and landing hook as I flew the aircraft downwind along the carrier's port side. Next came the gentle turn into the landing groove to sight the LSO, receive his "cut" signal, and make my first arrested landing on a carrier. Due to the sudden deceleration, when the hook engages the arresting wire, one must lock the canopy open, remove the hand from the throttle, and remove the feet from the brakes. I forgot all three. When my Wildcat hit the deck and grabbed the cable, the canopy slammed forward, my hand shoved the throttle to full power, and my feet applied the brakes! The Wildcat's nose went down and the tail went up. With luck, no damage was done.*[153]

The two carriers had certain limitations such as having no elevators or a hangar deck. When barrier crashes or other flight deck crashes used up the allotted spots on the flight deck for parking dud aircraft, the day's operations were over and the carriers headed back to their pier in Chicago.[154]

During the course of World War II, over thirty U.S. aircraft carriers saw service; none were more unique than the two freshwater carriers converted from the most elegant of Great Lakes passenger steamships. Between them, the USS *Wolverine* and USS *Sable* facilitated approximately 116,000 carrier landings. *Sable* set a record with 528 landings and takeoffs in one day.[155] A total of 17,820 pilots were qualified for combat carrier duty on the two ships and another 40,000 sailors were trained to be part of fleet carrier deck crews. With the war's end in 1945, the vessels' critical mission was completed, and the two innovative ships, the only steam-powered, side-wheel aircraft carriers in the history of the United States Navy, were decommissioned and eventually broken up for scrap.

Chapter 7

The Last Generation

Take your car with you! Save wear and tear on your nerves as well as your car by shipping it on the S.S. Theodore Roosevelt. There's no traffic interference or delay on the lake—spend comfortable, carefree hours and arrive on schedule—fresh as a daisy.
—*1937 brochure*

The passenger and freight traffic—motivating factors in the development and growth of the passenger steamship industry on Lake Michigan and the other Great Lakes—began to slow down due to competition from railroads as far back as the mid-1800s. By the 1890s, the competition from expanding railway service caused a shift toward excursion and cruise services, however, point-to-point transportation of passengers and freight was still important for passenger steamships on the lake. Although the level of passenger travel was not as robust as owners may have liked, it was still significant; passenger steamships calling at Chicago alone served over two million passengers a season in the first decade of the twentieth century.[156]

The advent of the automobile added to the competition in the teens and twenties. But without a system of good roads throughout the Midwest, early automobiles were not an overly troublesome competitor. Legislation, however, in the form of Senator La Follette's Seaman's Act in 1915 and other safety laws, put an unreasonable burden of specialized labor on the passenger steamship lines; this caused more damage to their sustainability than the competition from other transportation types. This, followed by

Steamer *Alabama*, built 1910, provided five-day and weekend excursion cruises on the Chicago, Mackinac Island and Sturgeon Bay routes. *Courtesy of the author.*

the Great Depression of the 1930s, created a devastating combination of economic woes which led to bankruptcy for many of the lines.

The last generation of passenger steamships on the Great Lakes were mostly built after 1900 and included the *Theodore Roosevelt, City of Grand Rapids, Juniata* (later *Milwaukee Clipper*), *Seeandbee, Manitou* (later *Isle Royal*), *South American, North American, Alabama, City of Midland* and others. This generation had some of the largest and grandest steamships ever known on the lakes; and while the palatial side-wheelers *City of Detroit III, Seeandbee, Greater Buffalo* and *Greater Detroit* were originally intended for the lower lakes, all eventually steamed to ports on Lake Michigan, most as part of the cruise experience of the 1930s and after.

Despite a temporary increase in business during World War II, new factors soon dealt a final blow to the Lake Michigan steamship industry. By 1947, the system of dependable roads—which had been missing in the teens and twenties—were largely in place throughout the Midwest, making travel and vacation by automobile more desirable, especially when combined with abundant and cheap gasoline. This also impacted the freight

The Last Generation

side of the steamship business as trucking evolved into a primary competitor. Additionally, the emerging availability of air travel to the coasts opened up opportunities for midwesterners to more easily take advantage of year-round cruise ship opportunities not available on the inland seas.

For the handful of grand, graceful passenger steamships that managed to survive the Great Depression, the end was still not far away. Over the next two decades, almost all met a fate described by phrases such as "sold for scrap," "burned in preparation for scrapping" and "broken up."

Fortunately, the sights associated with the majestic steamships of the Great Lakes have not entirely vanished, and a few opportunities still exist to catch a glimpse of this most interesting chapter in the transportation history of the United States and Canada.

The SS *Badger* is the largest car ferry ever to sail Lake Michigan. At the time of this writing, it is still in operation, ferrying passengers and automobiles daily on a route between Ludington, Michigan, and Manitowoc, Wisconsin, during the spring-to-fall season. Launched in 1953, the *Badger* is reportedly the only coal-fired steamship in operation in North America, maintaining a unique propulsion system that has been designated as a national mechanical engineering landmark. The *Badger* was designed for year-round transportation of railroad freight cars and passengers across Lake Michigan

Steamer *Badger* is seen on Lake Michigan in 2007. *Courtesy of Lake Michigan Car Ferry Service.*

and "reigned as Queen of the Lakes during the car ferries' Golden Era in the late Fifties." Listed on the National Register of Historic Places by the U.S. Department of the Interior, the *Badger* offers a unique opportunity to experience a genuine cruise across Lake Michigan by steamship.[157]

Permanently moored at the northwest end of Michigan's Manistee Lake along U.S. 31, the SS *City of Milwaukee* is a passenger and railroad car ferry steamer preserved for the public and is listed on the National Register of Historic Places. The last of six sister ships designed and built by the Manitowoc Shipbuilding Company, the *City of Milwaukee* was launched on November 25, 1930, and was considered "the aesthetic pinnacle of car ferry design." Built to replace the SS *Milwaukee*, which foundered during a severe storm in 1929, the steamship was designed to accommodate an entire freight train—32 boxcars on four tracks—and 300 passengers. For most of its active career, the *City of Milwaukee* served the Grand Trunk Western Railroad but was leased and operated by other railroads around Lake Michigan over the decades. In 1979, the ship was purchased by the State of Michigan to operate as an Ann Arbor Railroad vessel and was retired in operable condition in 1981 when the state shut down its cross-lake ferry system.[158]

The steamer *Keewatin* served for over fifty years as a railway link connecting the Georgian Bay and upper Lake Superior railheads. Considered by many "the last of the classic Great Lakes passenger steamships still afloat," the ship was built in Scotland for the Canadian Pacific Railway and delivered to the Great Lakes in 1907. Like Great Lakes passenger steamers commandeered for service during the world wars, the *Keewatin* was cut into two sections for passage through the Welland Canal—but in this case, it was on the way to the Great Lakes. The *Keewatin* was an elegantly furnished vessel capable of berthing 288 passengers and carrying a crew of 86 before being retired from service on November 29, 1965. A floating museum at Douglas, Michigan, since 1968, the ship is open to the public for tours between Memorial Day weekend and Labor Day and is a carefully preserved example of the Edwardian elegance passenger steamers displayed in the first decades of the twentieth century.[159]

The *Milwaukee Clipper* claims the distinction of being "the oldest American passenger steamship on the Great Lakes." The ship was built as the *Juniata* in 1905; in 1940, she was extensively rebuilt as the *Milwaukee Clipper*. "The entire ship reflected the new aesthetic streamlining of the Art Moderne style." The rebuilt ship, now a passenger and automobile ferry, served the

The Last Generation

This photograph, including the insets, show the steamer *Milwaukee Clipper*. *Courtesy of the S.S. Milwaukee Clipper Preservation, Inc.*

Deck plan for the sister ships *North Land* and *North West* in 1910. *Courtesy of the author.*

route between Milwaukee, Wisconsin, and Muskegon, Michigan, from 1941 to 1970. During the war years—1942 to 1945—she ran between Milwaukee and Chicago during weekdays and Milwaukee and Muskegon on weekends. The *Milwaukee Clipper* is currently moored at 2098 Lakeshore Drive in Muskegon, Michigan.[160]

Notes

Vanished Industry

1. George W. Hilton, *Lake Michigan Passenger Steamers* (Stanford, CA: Stanford University Press, 2002).
2. James Stuart, *Three Years in North America, Vol. II.* (Edinburgh, Scotland: Robert Candell, 1833).
3. Lawrence H. Officer and Samuel H. Williamson, http://www.measuringworth.com.
4. Thurlow Weed, *Albany Evening Journal*, 1847.
5. "History and Development of Great Lakes Water Craft," Minnesota Historical Society.
6. Hilton, *Lake Michigan Passenger Steamers.*
7. Alfred Theodore Andreas, *History of Chicago: From the Earliest Period to the Present Time, Volume 1,* (Chicago: A.T. Andreas, 1884).
8. J.B. Mansfield, *History of the Great Lakes in Two Volumes,* (Chicago: J.H. Beers, 1899).
9. *Cleveland Daily Herald & Gazette,* September 19, 1837.
10. This was an inaccurate belief of the time. Lake Superior is actually the deepest of the Great Lakes.
11. Mansfield, *History of the Great Lakes.*
12. http://www.measuringworth.com.
13. Thomas Horton James, *Rambles in the United States and Canada During the Year 1845* (London: John Ollivier, 1846).

14. Theodore J. Karamanski, *A Nationalized Lakeshore: The Creation and Administration of Sleeping Bear Dunes National Lakeshore* (National Park Service, Department of the Interior, 2000).
15. *The Ohio Architect, Engineer and Builder* (May 1912).

IMMIGRATION AND WESTWARD EXPANSION

16. "The Steamboat Era in Illinois," University of Illinois, Champaign, IL.
17. Weed, *Albany Evening Journal*.
18. Mansfield, *History of the Great Lakes*.
19. http://www.measuringworth.com.
20. Andreas, *History of Chicago*.
21. *The History of Wisconsin vols. 2 and 3* (Madison, WI: State Historical Society of Wisconsin).
22. Theodore Christian Blegen, *Land of Their Choice* (St. Paul, Minnesota: University of Minnesota Press, 1955).
23. Ibid.
24. Sir Henry Morton Stanley, *The Autobiography of Sir Henry Morton Stanley* (Cambridge: Houghton Mifflin / Riverside, 1911).
25. Margaret Fuller, *Summer on the Lakes, in 1843* (Boston: C.C. Little and J. Brown / New York, C.S. Francis, 1844.).
26. William Vipond Pooley, *The Settlement of Illinois from 1830 to 1850* 220 (Madison, WI: Bulletin of the University of Wisconsin, 1908).
27. From a written account by Amund O. Eidsmoe, 1852, translated by Sever Barnhard Eidsmoe, Amund Eidsmoe's grandson. http://www.eidsmoe.com.
28. Letter by Christian H. Jevne, 1864, in *An Immigrant in Chicago, 1864* vol. 3 by the Norwegian-American Historical Association (Northfield, MN, 1928), 67–72.
29. Letter by Lars Davidson Reque, 1839, in "A History of Norwegian Immigration to the United States from the Earliest Beginning Down to the Year 1848," by George Tobias Flom, private printing, 1909
30. Jevne, *An Immigrant in Chicago*.
31. Letter by Captain Johan Gasmann, 1844, as published in *Land of Their Choice* by Theodore Christian Blegen (St. Paul: University of Minnesota Press, 1955).

The Passenger Experience

32. Lansing B. Swan, journal of a trip to Michigan in 1841 (Rochester, NY: 1904).
33. Margaret Hunter Hall, *The Aristocratic Journey: Being the Outspoken Letters of Mrs. Basil Hall Written During a Fourteen Months' Sojourn in America, 1827-1828* (New York: G.P. Putnam's Sons, 1931).
34. *Green Bay and Lake Michigan Summer Resorts*, brochure for the steamer *Charles McVea* (Green Bay, WI: Waggoner & Roulett Steamboat Line, 1907).
35. Fuller, *Summer on the Lakes*.
36. James, *Rambles in the United States and Canada*.
37. Hall, *Aristocratic Journey*.
38. Weed, *Albany Evening Journal*.
39. Stanley, *Autobiography of Sir Henry Morton Stanley*.
40. Weed, *Albany Evening Journal*.
41. Constance Fenimore Woolson, "Round by Propeller," *Harper's Magazine* 45, no. 268 (September 1872).
42. Stanley, *Autobiography of Sir Henry Morton Stanley*.
43. James, *Rambles in the United States and Canada*.
44. Stanley, *Autobiography of Sir Henry Morton Stanley*.
45. Weed, *Albany Evening Journal*.
46. Hall, *Aristocratic Journey*.
47. Charles Lyell, *Travels in North America, In the Years 1841-2* (New York, Wiley & Putnam, 1845).
48. Charles Dickens, *American Notes for General Circulation* (London: Chapman and Hall, 1842).
49. Lansing B. Swan, Journal of a trip to Michigan in 1841 (1904).
50. James, *Rambles in the United States and Canada*.
51. Fuller, *Summer on the Lakes*.
52. Charles Latrobe, *The Rambler in North America* (New York: Harper and Brothers, 1836).
53. Ibid.
54. Weed, *Albany Evening Journal*.
55. Swan, journal.
56. Lyell, *Travels in North America*.

57. Sir Henry Morton Stanley, *My Early Travels and Adventures in America and Asia, Volume 1*, (New York: C. Scribner's Sons, 1895).
58. James, *Rambles in the United States and Canada*.
59. Latrobe, *Rambler in North America*.
60. Dickens, *American Notes for General Circulation*.
61. Latrobe, *Rambler in North America*.
62. Stanley, *My Early Travels and Adventures*.
63. Weed, *Albany Evening Journal*.
64. Woolson, "Round by Propeller."
65. "A Pioneer's Stormy Voyage by E.A.C.," Wisconsin Historical Society.
66. *Desert News* (Salt Lake City, UT), daily journals of Wilford Woodruff, fourth president of the Church of Jesus Christ of Latter-day Saints, 1909.
67. James T. Lloyd, *Lloyd's Steamboat Directory, and Disasters on the Western Waters* (Cincinnati, Ohio: James T. Lloyd Co., 1856).
68. *New York Times*, "Latest Intelligence; Burning of the Steamer *Niagara*," September 26, 1856.
69. *New York Times*, "The Lake Michigan Calamity; Further Particulars of the Loss of the *Lady Elgin*," September 12, 1860.
70. *St. Joseph* (MI) *Herald*, "The Loss of the *Hippocampus*. Fifteen of the Passengers and Crew Saved—Twenty-six Lives Lost. Statement of Captain Brown," September 19, 1868.
71. *Waukesha* (WI) *Plaindealer*, "The *Sea Bird* Disaster. Further Particulars of the Terrible Calamity on Lake Michigan," April 14, 1868.
72. *New York Times*, "A Terrible Disaster on Lake Michigan. The Propeller *Vernon* Wrecked and from Thirty to Fifty Lives Supposed to be Lost," October 31, 1887.

Working the Lakes

73. Mansfield, *History of the Great Lakes*.
74. Elbridge Streeter Brooks, *The Story of the American Sailor in Active Service on Merchant Vessel and Man-of-War* (Boston: D Lothrop, 1888).
75. George Trimble, *The Lake Pilots' Handbook* (Port Huron, MI: Riverside Printing, 1907).
76. Mansfield, *History of the Great Lakes*.

77. Woolson, "Round by Propeller."
78. Stanley, *My Early Travels and Adventures*.
79. Weed, *Albany Evening Journal*.
80. Mansfield, *History of the Great Lakes*.
81. Mansfield, *History of the Great Lakes*.
82. *Freeman Illustrated Colored Newspaper* (Indianapolis, IN), Stoker's Part, May 7, 1898.
83. Trimble, *Lake Pilots' Handbook*.
84. Ibid.
85. Mansfield, *History of the Great Lakes*.
86. James, *Rambles in the United States and Canada*.
87. Woolson, "Round by Propeller."
88. Mansfield, *History of the Great Lakes*.
89. Brooks, *Story of the American Sailor*.
90. *Chicago Record* as quoted in J.B. Mansfield's *History of the Great Lakes*.
91. Mansfield, *History of the Great Lakes*.
92. Brooks, *Story of the American Sailor*.
93. *Chicago Times Herald* as quoted in J.B. Mansfield's *History of the Great Lakes*.
94. Ibid.
95. "Crew of a Lake Liner," *Midland Monthly* 7–8 (1897).
96. Mansfield, *History of the Great Lakes*.
97. "Crew of a Lake Liner," *Midland Monthly*.
98. Mansfield, *History of the Great Lakes*.

Early Twentieth-Century Steamers

99. *S.S. SEEANDBEE Vacation Cruises* (Chicago: C&B Line).
100. *Waggoner & Roulett Steamboat Line Season 1907* (Green Bay, WI: Waggoner & Roulett Steamboat Line, 1907).
101. *Great Lakes Cruise—Finest in the World* (Buffalo, NY: Great Lakes Transit Corporation, 1917).
102. *Delightful Lake Cruises—S.S. Roosevelt* (Manitowoc, WI: Chicago Roosevelt Steamship, 1937).
103. *Great Lakes Cruise—Finest in the World*.
104. *Waggoner & Roulett Steamboat Line Season 1907*.

105. *Delightful Lake Cruises—S.S. Roosevelt.*
106. *Lake Excursions—Moonlight Cruises* (Chicago: Chicago–Milwaukee Steamship Line, 1937).
107. James Oliver Curwood, *The Great Lakes: The Vessels That Plough Them, Their Owners, Their Sailors* (New York: G.P. Putnam's Sons, 1909).
108. Curwood, *Great Lakes.*
109. Ibid.
110. James Cooke Mills, *Our Inland Seas: Their Shipping & Commerce for Three Centuries* (Chicago: A.C. McClurg, 1910).
111. Ibid.
112. Ibid.
113. *NORTH WEST—NORTH LAND* (Buffalo, NY: Northern Steamship Company, June 1910).
114. Mills, *Our Inland Seas.*
115. Ibid.
116. Hubert Howe Bancroft, *The Book of the Fair* (Bancroft, 1893).
117. Geo. Thomson, *Impressions of America* (Arbroath, UK: T. Buncle, 1916).
118. Mills, *Our Inland Seas.*
119. Ibid.
120. Ibid.
121. Ibid.
122. Ibid.
123. Ibid.
124. Ibid.
125. Ibid.
126. *Eastland Disaster Relief, American Red Cross, 1915–1918* (Chicago: American Red Cross, 1918).
127. Ibid.
128. *New York Times*, "300 Saved from Burning Steamer; Passengers Asleep When Fire Is Discovered on the City of Chicago. Wireless Fails to Work; Captain Runs Boat Head On Into Breakwater and Saves All-Plight Seen from Shore," September 2, 1914.
129. Curwood, *Great Lakes.*

War on the Lakefront

130. "A Timeline of the Black Hawk War," Wisconsin Historical Society, http://www.wisconsinhistory.org.
131. Francis Whiting Halsey, *The World's Famous Orations—America: Volume I* (New York: Funk and Wagnalls, 1906).
132. *Fergus' Historical Series*, no. 16 (Chicago: Fergus Printing, 1881), 72–76.
133. Andreas, *History of Chicago*.
134. *Fergus' Historical Series*, No. 16, Appendix (L), pp. 72-76 (Chicago, Illinois: Fergus Printing Co., 1881).
135. *New York Times*, "An Incident of War Times; Capture of the Lake Erie Steamer Philo Parsons by Rebels. Told by a Participant in the Affair; Unsuccessful Attempt to Free Several Thousand Confederates Imprisoned on Johnson's Island, Near Sandusky," August 11, 1895.
136. "The Chicago Conspiracy," *Atlantic* 16 (1865).
137. *New York Times*, "The Case of the 'Georgian'; The Examination of 'Larry' McDonald: He is Committed for Trial," April 29, 1865.
138. Hilton, *Lake Michigan Passenger Steamers*.
139. Mansfield, *History of the Great Lakes*.
140. Edward N. Hurley, *The Bridge to France* (Philadelphia: J.B. Lippincott, 1927).
141. *Grand Haven Evening Tribune*, May 29, 1891.
142. Mills, *Our Inland Seas*.
143. "USS Blue Ridge (ID # 2432), 1918–1919." Department of the Navy, Naval Historical Center. http://www.history.navy.mil.
144. Written statement of Captain Edward A. Evers, United States Naval Reserve Forces, as published in *Blue Book of the State of Illinois 1935–1936*, ed. Edward J. Hughes, secretary of state (State of Illinois).
145. *Woodville Republican*, July 9, 1921.
146. Ernie Pyle, *Home Country* (New York: William Sloane Associates, 1947).
147. Graeme S. Mount, "Myth and Realities: FDR's 1943 Vacation on Lake Huron," *Northern Mariner/Le marin du nord* 11, no. 3 (July 2001), 23–32.
148. Steven Duff, "From Cruiseship to Warship; The conversion of the Seeandbee and Greater Buffalo to the U.S.S. Wolverine and Sable." *Lakeland Boating* 55, no. 2 (February 2001).
149. *New York Times*, "The Navy's Newest Aircraft Carrier," May 9, 1943.

150. Bill Lee, "Paddlewheel Aircraft Carriers," http://www.nnapprentice.com/alumni/letter/PADDLEWHEEL_AIRCRAFT_CARRIERS_082109.pdf.
151. Ibid.
152. Steven Duff, "From Cruiseship to Warship."
153. Letter by Retired Lieutenant Commander G. Vaughn, United States Navy Reserve, Granbury, Texas, 2008, Paddle Wheel Aircraft Carriers, http://ix-carriers.blogspot.com/2008/09/fond-memories-of-landing-on-freshwater.html.
154. Richard A. "Chick" Eldridge, "A Look Back: Forty Years of Reminiscing," U.S. Naval War College, http://www.usnwc.edu.
155. Letter by Retired Commander F.C. Durant III, United States Navy Reserve, Jacksonville, Florida, 2008, Paddle Wheel Aircraft Carriers, http://ix-carriers.blogspot.com/2008/09/fond-memories-of-landing-on-freshwater.html.

The Last Generation

156. Mills, *Our Inland Seas*.
157. Lake Michigan Carferry Service, Ludington, MI, http://www.ssbadger.com.
158. SS *City of Milwaukee* National Historic Landmark, Inc., Manistee, MI, http://www.carferry.com.
159. The Keewatin Maritime Museum, Douglas, MI, http://www.keewatinmaritimemuseum.com.
160. The SS *Milwaukee Clipper* Preservation, Inc., Muskegon, MI, http://www.milwaukeeclipper.com.

Glossary

A few nautical and period terms that may not be familiar to modern readers are found in the quotes within this book. Here is a brief listing of some of these terms and their meanings:

Amidships: Any place on or below decks that is in the center of the vessel, whether in reference to the length or breadth.
Bulkheads: Partitions dividing various parts of the vessel.
Bulwarks: A solid wall enclosing the perimeter of a weather or main deck for the protection of persons or objects on deck.
Bunkers: Apartments for the steamer's fuel.
Burthen: Archaic form of *burden*, used to describe the total weight of a steamship.
Capstan: An apparatus used for hoisting weights, consisting of a vertical spool-shaped cylinder that is rotated manually or by machine and around which a cable is wound.
Deck hand: Laborers employed to do general unskilled labor on a steamship.
Deck passenger: Passengers who traveled with cheaper tickets and without a cabin, often sleeping on the deck of the steamer.
Firemen: Laborers employed to tend and fuel a furnace—especially a furnace used to generate steam, as on a steamship.
Fire room: The room in which the stoker or firemen tend the furnace.
Flotsam: Wreckage floating on the water.

Glossary

Fore: The forward part of a vessel; anything in the direction of the head of the ship.
Forecastle: The compartment in the forward part of a vessel in which the seamen sleep.
Galley: A ship's kitchen.
Gangplank: A movable bridge used in boarding or leaving a ship at a pier.
Gangway: The opening or door through the bulwarks.
Guards: The superstructure built over and around the revolving side-wheels of a side-wheel paddle wheeler.
Jack: The universal name for a sailor.
Lead: A lead weight with a line attached, used for finding the depth of water.
List: When a vessel leans over to either side she is said to have a list, but this term is not used when the vessel is borne over by the wind.
Lower Lakes: Term for Lakes Erie and Ontario.
Manifest: A document signed by the master and given to the customs authorities, showing the cargo and to what ports the cargo is destined, etc.
Offing: A distance to seaward.
Paddle wheeler: A vessel driven by a rotating mechanism of paddles at the sides or rear of the vessel.
Pilothouse: The compartment containing the wheel that steers the vessel and the pilot that guides the vessel.
Port: The left-handed side of a vessel looking forward.
Propeller: Name for a vessel driven by a screw shaft propeller.
Rudder: An instrument for steering a vessel.
Side-wheeler: Name for a vessel driven by a rotating mechanism of paddles at the sides of the vessel.
Starboard: The right-handed side of a vessel looking forward.
SS: Prefix designation for civilian ships that stands for steam ship.
Steamer: A vessel powered by a steam engine.
Steerage: An area below decks of a steamer designated for 'economy' travelers.
Steerage passengers: Passengers who traveled with cheaper tickets and without a cabin, often sleeping on the deck of the steamer.
Stevedore: Individual engaged in the loading or unloading of a vessel.

Glossary

Stoker: A laborer employed to tend and fuel a furnace—especially a furnace used to generate steam, as on a steamship.

Stoke hold: The room in which the stoker tends the furnace.

Stoke hole: A hole in a furnace through which the fire is stoked; also another term for the room in which the stoker tends the furnace.

STR.: Abbreviation for Steamer

Upper Lakes: Term for Lakes Huron, Michigan and Superior.

USS: Prefix designation for military ships that stands for United States ship.

Wake: The track left by a ship.

Wheelhouse: The compartment containing the wheel that steers the vessel and the pilot that guides the vessel.

Windlass: A device for raising or hauling objects, usually consisting of a horizontal cylinder or barrel turned by a crank or lever, upon which a cable, rope or chain winds; the outer end of the cable is attached directly or indirectly to the weight to be raised.

Yawl: A ship's small boat, rowed by a crew of four or six.

About the Author

Ted St. Mane is a historian and passenger steamship enthusiast who has spent several years researching the fascinating history of Lake Michigan's "lost" passenger steamship industry. Frequently engaged as a speaker on topics of local history, he is also co-owner and director of operations for MLT Group Advertising & Marketing in Rochester, Minnesota. His published works include books and documentaries on the rich history of America's Midwest.

Visit us at
www.historypress.net